Environmental Warfare
in Gaza

Environmental Warfare in Gaza

Colonial Violence and New Landscapes of Resistance

Shourideh C. Molavi
Foreword by Eyal Weizman

First published 2024 by Pluto Press
New Wing, Somerset House, Strand, London WC2R 1LA
and Pluto Press, Inc.
1930 Village Center Circle, 3-834, Las Vegas, NV 89134

www.plutobooks.com

British Library Cataloguing in Publication Data
A catalogue record for this book is available from the British Library

ISBN 978 0 7453 4457 7 Paperback
ISBN 978 0 7453 4461 4 PDF
ISBN 978 0 7453 4459 1 EPUB

This book is printed on paper suitable for recycling and made from fully managed and sustained forest sources. Logging, pulping and manufacturing processes are expected to conform to the environmental standards of the country of origin.

Typeset by Squareart Ltd, London

Printed in the United Kingdom

Cover image: Fading mural of oranges on the walls of the UNRWA Headquarters in Gaza City (Ain Media Gaza and Shourideh C. Molavi, 2019).

for Tiyam and Dania,
to drink the sea at Gaza like their parents

Contents

Foreword:
The Climate of Israeli Colonialism

By Eyal Weizman

In an area of sand dunes roughly at the center of the Gaza Strip the sea-line slowly starts its 90-degree turn from its lusher eastern Mediterranean coasts of Syria, Lebanon, and Palestine to the relatively barren north African littoral of Egypt, Libya, Tunisia, and Algeria. In Palestine the prevailing westerly wind, pregnant with humidity gathered from over the Mediterranean, blows into the land irrigating fields and wells, but as the coast turns, wind no longer reaches deep beyond the coastline and annual rainfall decreases rapidly.

In and around Gaza, these climatic conditions meet political ones. The desert edge is here not only environmental, but also a political line, weaponized by Zionist colonization as a tool of dispossession and control. The desert has been mobilized as part of a siege that surrounds the Gaza Strip alongside a complex system of fortifications that Israel calls the "Gaza Envelope." These include several layers of razor-wire fences, concrete walls extending underground, towers, ramparts, security roads and the electronic systems that weave them together. Beyond this are a series of military bases, some of them near or inside the agrarian civilian settlements constructed on land belonging to the Palestinian villages of Dayr Sunayd, Simsim, Najd, Huj, Al Huhrraqa, Al Zurai'y, Abu Sitta, Wuhaidat, and to the Tarabin and Hanajre Palestinian Bedouin tribes, made refugees in the besieged Gaza Strip. This was the interlinked system dismantled by Hamas operatives on October 7, 2023.

The siege over Gaza includes the damming of groundwater for the benefit of the Israeli settlements surrounding Gaza. On the Israeli controlled side are miles of field crops—strawberries, melons, herbs, and cabbages—irrigated by state-of-the-art watering systems and benefiting from the majority of aquifer waters. To the eyes of the colonizer, looking from across the fences, Palestinian lands seem like dead lands. It wasn't always like that, from the time of the British Mandate to the turn of the twenty-first century, as this book makes clear, despite displacement and occupation, the area was plentiful with orange groves, fruit orchards, and sustenance fields. All this is now gone. East of the siege lines, the landscape immediately turns dry. It includes a hundreds-of-meters-wide liminal zone in which the mere presence of any agriculture at all is based on nothing but the ingenuity of its Palestinian farmers, cultivating with little available water.

The desertification of the perimeter of Gaza is part of the mechanism of its control. Israel routinely sends its bulldozers over the fence to uproot crops and destroy plantation and green houses. As a Forensic Architecture investigation initiated and coordinated by Shourideh Molavi strongly demonstrated, Israel continuously expanded the military no-go area—or 'buffer zone'. Its use of aerial crop-dusters to spray a toxic plant-killing herbicide mobilized the wind to carry toxic clouds into Gaza territory, destroying agricultural lands hundreds of meters away. Bulldozers on land and toxic clouds in the air, transformed a once lush and agriculturally active border zone into parched ground, cleared of vegetation, a colonial made desert.*

This 'desertification' provided the Israeli military with uninterrupted lines of sight and fire into Gaza, leaving Palestinian civilians, including farmers, youth and families, exposed to Israeli sniper fire. In this hundreds-meter-thick buffer zone, more than two hundred Palestinian demonstrators were shot and killed in the 2018–19 demonstrations of *The Great March of Return* and thousands more maimed.

The desertification of Gaza is presented as a retroactive proof for a core element of Zionist ideology—one that imagined Jews as having returned to a desolate, neglected "dead land," and having revived it. This is the core of the Zionist meteorological imaginary of "making the desert bloom."

The Nakba, the loss of a Palestinian homeland starting 1947, is made out of a sequence of acts, massacres, enforced displacements, land dispossession, settlement, and the ongoing daily violence meant to repress the desire for liberation and the hope of return. The Nakba has also a lesser-known environmental dimension, the complete transformation of the environment, the weather, the soil, the loss of the indigenous climate, the vegetation, the skies. The Nakba is a process of colonially imposed climate change.

Going through a number of areas and local histories, this book brilliantly shows how violence unfolds across multiple scales and durations; how indirect, diffused transformations that are so slow as to become almost imperceptible, explode in incidents of eruptive violence. Reading the history of the interaction between environmental transformation and colonial conflict—"environmental violence"—is met with Molavi's skillful navigation between different kinds of source materials and brings together analysis undertaken on different scales. The book's strength is in its close contact with the people that inhabit and cultivate these liminal zones, relationships built over decades of scholarly and activist work. It amplifies these voices

* Forensic Architecture, "Herbicidal Warfare in Gaza". Retrieved from: https://forensic-architecture.org/investigation/herbicidal-warfare-in-gaza (Project Coordinator Shourideh C. Molavi; Research: Samaneh Moafi, Stefan Laxness, Grace Quah; Project Support: Sarah Nankivell; Principal Investigator: Eyal Weizman).

with echoes from literature, geology, archaeology, botany, meteorology, and photography. The book is carefully tuned into small-scale signals, such as those registered on the leaves of plants taken as sensors registering their imprint with toxins, and then scales up to examine environmental conditions that are geographically vast and historically deep.

Seen from the point of view of colonial history, climate transformation is not the accidental and indirect consequence of conflict; the environment is not the collateral damage of history, but a tool in its arsenal of transformations, a form of government over land, peoples and the relation between them, the environment is one of the means by which colonial racism is enacted, land is grabbed, siege lines fortified and violence perpetuated.

Studying the environment may also suggest a path. Looking further into the future, caring for the life-giving capacity of the environment to restored health and equality, can also be the medium by which return and reparation are enacted.

Note on language

It is difficult to speak about Palestine in single words. Occupation. Apartheid. Borders. Warfare. Return. Resistance. Each term used in describing the hyper-militarization of the Palestinian landscape and the everyday experiences of Palestinians is loaded with settler-colonial logics coded within our vocabulary. Words collide with lived realities and settler-colonial violence which, when left unaddressed, become its handmaidens, reproducing colonial domination, violence camouflaged as liberal sensibilities, and power relations. And the legal and political categories we are often compelled to mobilize are within the domain of state powers: they are born out of the historical matrix of colonial movements to delimit challenges to their practices and disempower the forums available to anti-oppression interventions. This is particularly the case when it comes to knowledge production in and around ongoing colonial contexts like Palestine where language oppression surfaces as an additional form of domination aligned with other forms of oppression. Words like occupation, settler-colonialism apartheid and particularly as of recent, genocide, *feel insufficient* in isolation and demand to be fleshed out when describing the daily traumas, erasure, and terror endured by Palestinians. And so, the single words applied to Palestine then invite longer sentences, paragraphs even, describing the careful nuance with which these words are applied to reflect lived experiences—all of which together reveal a collective longing for a new vocabulary to help us describe our present colonial circumstances.

An implicit responsibility therefore falls on researchers, students, and thinkers of conscience speaking on Palestinian liberation to actively consider the relations of domination and historical erasures that follow when specific terms and lexicons of identification are applied. Here strategies for building a different vocabulary, modes of annunciation, and representational forms that are decolonial become central to any anti-oppression research and investigation on Palestine. For example, referred to in the dominant literature as the 'Gaza Strip'—and theorized in the field as a single geographic unit—this area is an engineered enclave slowly enclosed and detached from the rest of Palestine through multifaceted Israeli colonial practices. Today, collective acts of resistance such as the Great March of Return and the Breaking of the Siege launched in 2018 on the 70th anniversary of the Palestinian catastrophe of 1948 (or *Nakba*) are efforts by Gazans to emphasize their connectedness and oppose Israel's colonial division of space. And yet, identifying this area by the colonial demarcation of the 'Gaza Strip' reproduces this oppressive logic. It neglects that this area contains numerous key cities in Palestine only one of which is the city

of Gaza. In fact, as far back as the 1850s, Gaza itself was the second-largest city in Palestine and constituted a key regional trade center. In our excursus, 'Gaza,' 'Gazan territory,' and the 'Gaza Strip' are used interchangeably. These terms refer to the 365 kilometer-squared coastal territory south-east of Palestine bordering with Egypt—today living under multifaceted systems of control: a decades-long blockade, enforced by military occupation, and mediated by an apartheid system of domination that is guided by broader settler-colonial logics of erasure. At the time of writing, this same coastal strip is also being massively bombarded by Israeli airplanes, under the watchful eyes of Western and European powers, with unprecedented and excruciating human and infrastructural devastation. While employing this grammar to describe this southern part of Palestine, the book interrogates and opposes the colonial relations that have produced the contemporary Gaza Strip as a single unit. This strategy involves acknowledging the historical, political, and cultural importance of Gaza, its links to the rest of Palestine, and the unique practices and character of the various cities— including, Beit Lahiya, Beit Hanoun, Shejaiyeh, Khan Younes, Deir el Balah, Rafah, and others—regularly packaged under the colonial label of the 'Gaza Strip.'

Similarly, this project began as a study into the disappearing trees of Gaza. But to engage the orange and olive orchards in the territory and communicate their testimony as silent witnesses and bio-indicators of settler-colonial violence means also to speak of the terrain on which they once stood. In the case of Gaza, the terrain where the orchards stood today forms its borders. But to describe the area around the constructed Gaza Strip as its 'borders,' is also misleading. The use of a term like 'border' in this context falsely implies the sovereign and state-like character of the Gaza Strip—an area that continues to be, in law, infrastructure and practice, an occupied enclave. As such, I employ the terms 'border,' 'border area,' 'perimeter,' 'fence,' and 'frontier' interchangeably. In our investigation of the various slow historical violences that have produced contemporary juridico-political realities in Palestine, and in Gaza specifically, these terms will be employed to refer to the space surrounding and delimiting this enclosed area over time and space. While mobilizing this problematic lexicon of terms that in the end *do not feel right* when speaking of Gaza, I hope to challenge the underlying assumptions of this grammar of borders by pointing to the ways in which the 'border' is violently maintained by the State of Israel— engineered and fluid through the mentioned interlocking political systems of settler-colonialism, apartheid, and military occupation. Overall, far from

a juridico-political geographic divide demarcating two sovereign powers, the 'border' as applied here is examined as working from a relationship of rejection and non-identification of Palestinian-Arabs—whether citizens, residents, or refugees. As a one-directional extension of Israeli sovereignty and a tool for colonial erasure that delimits and maintains the enclosed and occupied Gaza Strip, the border is our starting place for discussing the ways contemporary Israeli coloniality mobilizes environmental elements and space.

Relatedly, the importance of history when building our lexicon for describing colonial violence becomes more vital during moments of anti-colonial eruption. On the morning of Saturday 7 October 2023, the military arm of the Islamic Resistance Movement, *Hamas*, supported by other Palestinian factions based in the occupied Gaza Strip launched 'Operation Al-Aqsa Flood'. Most Western national newspapers and commentators immediately began reporting, many repeating the same mantra: the Palestinians started a war against Israel. The *Independent* reports that "Israel retaliates with strikes," the *New York Times* reports that "Hamas attacks and Israel declares war," while the *Sunday Telegraph* calls it Israel's "9/11 moment." Throughout this coverage, and not unlike the media framing of the September 2001 attacks at the time, 'Operation Al-Aqsa Flood' is consistently treated as the 'year zero', with mainstream press and popular culture representing Israeli warfare as a new development in response to *Hamas's* surprise attack.

To develop a vocabulary to describe the events of 7 October, and the unprecedented suffering playing out on the civilian population in Gaza, demands the placement of these events within the broader history of the Palestinian liberation movement. For people of conscience, an absolute commitment to correct definitions that are in line with the historical record and a moral compass permanently calibrated towards an anti-oppression and liberatory politics is vital. This requires the use of language that does not legitimize the colonizer's violence, but which, in the case of Palestine, places Israeli policies and practices within a genealogy of European colonial racism that has manifested itself on the land in a settler-colonial manner. The struggle in Palestine is a struggle for liberation, an anti-settler-colonialist struggle, and as historian Ilan Pappe reminds, like its historical predecessors this liberation movement too has moments of purported gains and 'victory' and, also, carnage. And we have seen time and time again that the intensity of this decolonial process is often in proportion to the level and depth of the colonial aggression being confronted. Thus, while one may wish to question the tactics of this struggle, its strategy, ideas, and actions, our vocabulary when describing these events ought to be calibrated in relation to the historical political context within which they are playing out.

Put differently, the written record of Israel's piecemeal *Nakba* policies on the Palestinian people is longer and deeper than the events of 7 October. And so, this record obliges us to understand 'Operation Al-Aqsa Flood' not as a momentary or one-off attack, but rather as an uprising that forms the latest stage of an anti-colonial struggle for self-determination. In this spirit, the landscape of colonial violence and anti-colonial resistance in Gaza that is described in this book is part of an effort to build a vocabulary to understand our present moment of struggle in Palestine.

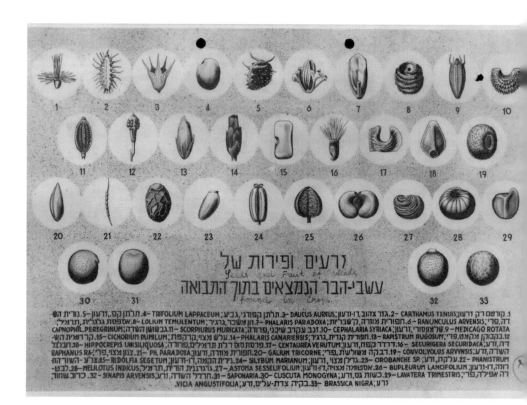

1. Archival image of an illustration of the common "seeds and fruits of weeds found in crops" in Palestine and their scientific names, part of the British Mandate's "Traveling Weeds Exhibition" in 1940. Exhibited in Spring 2020 at the *A.M. Qattan Foundation* in Ramallah, Palestine (*Weed Control*, 2020, A.M. Qattan Foundation).

Introduction

Colonial legacies of farm warfare

In a British Mandate document titled "Control of Weeds (Including Experiments)," more than 45 letters to the Department of Agriculture and Fisheries from all regions in Palestine are included on issues related to weeds and the harm they inflict. One of these letters, dated 16 January 1940, is addressed to Mr. Masson, the Chief Agricultural Officer at the Department of Agriculture and Fisheries in British Mandate Jerusalem, and outlines a traveling exhibition in Palestine of weeds and seeds. A strange type of propaganda tour, the exhibition was accompanied by a public program of lectures on methods of weed control, including photos of illustrations of the weeds, their botanical names, and the seeds most common in Palestine. A large share of the correspondence in the collection of letters also features copies of scientific research carried out between Britain and Mandate Palestine, in particular by the Imperial Chemical Industries (Levant). The research outlines statistics and field experiments on Methoxone and other chemicals to curb crop weeds and manage their propagation and growth.

This project of colonial engineering was the topic of a 2020 traveling exhibition and decolonial public program at the Ramallah-based *A.M. Qattan Foundation*, titled *Weed Control*. Profaning the traveling weeds exhibition of 1940, 33 artists were provided 33 seeds based on the colonial illustrations of the most common weeds in Palestine and invited to unlearn the botanical anatomy of their given weed, transforming the seed into a sculpture that confronts the British colonial and industrial (de)valuing of the seed. The curator of the exhibition, Yazid Anani stated that:

> The Western scientific taxonomy of plants had suddenly classified many of the domestic species as harmful weeds, to which they introduced pesticides and other new methods of control alongside awareness campaigns and publications. The repercussions of this historical turning point have echoed into the present. Knowledge of plants as part of the identity of the geography and people of Palestine has been limited to a utilitarian thesis.[1]

The decolonial framework of *Weed Control* explores the forced transition in the perception of Palestinian flora and vegetation along with its historical ecological place in the social fabric and lives of Palestinians—particularly with the rise of early agroindustry. Industrialized forms of market-driven

crop farming in the country during the British Mandate also uprooted the household usage of plants, including their medicinal, cultural, and folkloric place in the Palestinian social fabric. In doing so, this experiment in weed control is an ideal example of the intimate interlacing of the practices of colonial erasure, knowledge production, and territorial domination.

Our language and metaphors about the environment reflect and impacts how we perceive and manage it. The scientific discourse on 'invasive species' of vegetation is dominated by violent representations of 'aliens' and 'invasion,' contributing to the promotion of combative control over the land—and by extension, its people. Labeling these plants as weeds renders them invasive and is itself a claim on what is accepted as *native* to the Palestinian terrain. Categorized as invasive plants, the mythical and practical dimensions of their everyday use by the indigenous community simultaneously becomes a 'nuisance'—a hindrance toward enlightened understandings of growth, development, profit, and, by extension, societal progress. In this process, it is not only the weeds themselves that become 'natural enemies' of the land, but also the indigenous Palestinian community by extension.

Settler-colonialism is a form of domination that violently disrupts human relationships with their environment. Strategically undermining the collective continence of indigenous communities on the land, settler-colonialism is ecological dominance, erasing the qualities of relationships that matter to indigenous peoples. According to Kyle Whyte, settler-colonialism is a form of colonization in which the colonizer chooses to 'settle' in the homeland of another community and where those settlers then seek to "erase Indigenous economies, cultures, and political organizations for the sake of establishing their own."[2] Whyte continues to explain that, in settler-colonial projects throughout the world, "settler populations are working to create their own ecologies out of the ecologies of Indigenous peoples, which often requires that settlers bring in additional materials and living beings."[3] As a framework of indigenous environmental justice, settler-colonialism therefore confirms the systemic reasons for which indigenous peoples are disproportionality impacted by disruption of nature and the environment as compared to other marginalized and precarious groups.

The "profound epistemic, ontological, cosmological violence" produced by this disruption, borrowing the words of Eve Tuck and K. Wayne Yang, are derived from a reality where colonial violence is foremost an ecological violence.[4] But it is the social dimensions of this ecological violence—what J.M. Bacon dubs the "eco-social structure" of settler-colonialism—that is of particular significance. Organizing life through an ongoing occupation of land and appropriation of culture, settler-colonialism informs practices across societal domains that actively obscure or erase indigenous peoples.[5]

Indeed, its traces are seen and felt across all levels of socio-political relations, from the international to the interpersonal. Together, these frameworks are useful for linking the disruption of eco-social relations to the structuring force of colonial violence. At the same time, scholars in indigenous studies and settler-colonial studies have also shown the ways in which traces of settler-colonial disruption are themselves subject to erasure.[6] Here the division between indigenous and settler—or colonizer and colonized—is diluted or normalized within public consciousness, conferring indigeneity upon the settler population and state.[7]

Described by Wolfe (2006) as "elimination of the native," this mechanism of settler-colonialism enables its reproduction through replacement via destruction. As a result, these forms of elimination and the aggressive agricultural self-identification by the colonizer that follows mark themselves also on the land, leaving scars that shape perceptions of place. Wolfe outlines this process of replacement in relation to the *Nakba* of the Cherokee, the 'Trail of Tears' which took place over the winter of 1838–1839: one of many comparable catastrophes where indigenous from the southeast were removed and displaced westward of the Mississippi River to make available their lands for the expansion of the deep South's slave-plantation economy. He explains that:

> [I]f the natives are already agriculturalists, then why not simply incorporate their productivity into the colonial economy? [...] When it came to [the Cherokee removal], the factor that most antagonized the Georgia state government... was not actually the recalcitrant savagery of which Indians were routinely accused, but the Cherokee's unmistakable aptitude for civilization. Indeed, they and their Creek, Choctaw, Chickasaw and Seminole neighbours, who were also targeted for removal, figured revealingly as the "Five Civilized Tribes" in Euroamerican parlance. In the Cherokee's case, two dimensions of their civility were particularly salient. They had become successful agriculturalists on the White model, with a number of them owning substantial holdings of Black slaves, and they had introduced a written national constitution that bore more than a passing resemblance to the US one. Why should genteel Georgians wish to rid themselves of such cultivated neighbours? The reason why the Cherokee's constitution and their agricultural prowess stood out as such singular provocations to the officials and legislators of the state of Georgia—and this is attested over and over again in their public statements and

correspondence—is that the Cherokee's farms, plantations, slaves and written constitution all signified permanence. The first thing the rabble did, let us remember, was burn their houses.[8]

Elimination, or elimination through replacement, therefore, involves the simultaneous return of the indigenous, or native, in the form of an appropriated Other—a repressed figure against which settler-colonial society continues to be structured. In this manner, Wolfe explains that settler-colonial violence involves both the liquidation of the native as well as the "recuperat[ion of] indigeneity in order to express its difference."[9]

In the case of the ongoing settler-colonial project unfolding in Palestine, the destruction of the land in colonial projects is a topic of study common among researchers. This book is not meant to be read as an anthology of colonial history in Palestine, nor is it meant to be a comprehensive reading of decolonial land practices in the country. Instead, I aim to provide a contemporary reading of ecological violence in Palestine—specifically in Gaza—outlining the eco-social structure of present-day Israeli practices of colonial erasure and replacement. And so, while my starting point of analysis is anti-indigenous violence on the Palestinian landscape that shapes perspectives of placehood, identity, and forces novel practices of cultivation as survival as well as resistance, I am not attempting here to provide absolute accounts or definitions of what such ecological violence is or entails. I am also not trying to create a single theory of environmental injustice in Palestine— or in neo-colonial societies for that matter—that can somehow explain every mechanism of anti-indigenous violence. Rather the findings offered here on ecological domination in Gaza seek only complementarity with other approaches to violence and injustice across indigenous studies and related fields of *Nakba* studies, critical environmental justice studies and settler-colonial studies. My examination of the orange trees, and trees more broadly, in and around occupied Gaza, the engineered historical changes to the lands on which they stood, the colonial eco-imaginaries imposed on those lands, and their present-day activation in the Palestinian liberation struggle is far from a total history. Instead, I hope to bring to the fore an understanding of Palestinian politics and society in present-day Gaza—a part of Palestine to which access is extremely limited for researchers and therefore engaged site immersion is also largely absent from available scholarship—that highlights the particular typology of Israeli eco-coloniality in the besieged strip.

One-directional border

We are taught that a state needs a border. Central for statehood, a border both delineates and defines a country while acknowledging those sovereignties that exist beyond its limits. A juridico-political geographic divide demarcating the inside and outside, the border is conceptually two-dimensional and two-sided, with a single or partial yet distinct sovereignty on each. The width of any border belongs to no-one; a *terra nullius* that may be shared by multiple limited sovereign powers but is not ruled by any single power. Michael Sfard outlines that:

> [...] borders and barriers are concepts that cover the same ground and signify a two-way spatial restriction to those located inside and outside: When one *walls out* others one is simultaneously *walled in*. That is the *objective* trait of a physical barrier: it excludes on both of its sides. So does a border: a border is simultaneously an act of defining an *interior* and the *exterior*, claiming sovereignty in the *interior* and acknowledging the *other's* sovereignty in the *exterior*, simultaneously including and excluding local status to residents of each side.[10]

Understanding how contemporary Israeli coloniality mobilizes environmental space requires us to begin from the function of the border—and the ways in which the border is mobilized by the interlocking political systems of settler-colonialism, apartheid, and occupation in Israel/Palestine.

In the case of Israel, its major features of nation-statehood, including final territorial borders, notion of 'peoplehood,' and sovereign rule largely remain incomplete. As a result, its ability to create the categories of insider/outsider and citizen/foreigner become particularly interesting when one notes that Israel is the only internationally recognized state in the world without *de facto* final borders. Continued occupation, annexation, expropriation, expansion, displacement, forced transfer, practices of apartheid, and besiegement of the Palestinian population and their lands places Israel's borders, in practice, in continuous flux. Working from the relationship of rejection and non-identification of the Palestinian *other* by the state, the border within the Israeli 'incorporation regime' has only one side. When it comes to its division from Palestinian communities—whether citizens, residents or refugees—the borders of the state are one-directional. Sfard continues that:

This one-way barrier functions like a one-way mirror. Both deflect (people or light) from only one side. In the case of the separation fence, it is the Palestinian side that gets deflected. For Palestinians, the fence is both a physical barrier and a borderline. For Israelis the fence is neither. The fact that the barrier has only one side gives Israel an *inside*, without having to recognize that the area on the other side of the fence is an *outside*. While a border establishes distinct sovereignties on either side of it, this one-way fence with sovereignty only on one side creates moving lines of sovereignty. The border is a process, a verb rather than a noun.[11]

Evidently, Sfard is discussing Israel's Wall in Jerusalem and the West Bank. However, when examining exclusion in the context of an incorporation regime that spans contemporary Israel/Palestine as a single geographical unit, his conclusions regarding the barrier can here be broadened to describe the logic of exclusion to which all non-Jewish Palestinian political subjects are faced. Put differently, in the case of contemporary Israel/Palestine, understanding that 'the border is a verb' means that we are examining something that is multifaceted and multi-layered. The borders of the Jewish State are not at the periphery or margins of the territorial state itself: *Israel's borders are not at the border*. Rather, its borders, including the inherent logic of exclusion and *otherness* that this political-legal concept produces, are constantly moving, and with various violent intensities bleed across the categories of citizen, immigrant, resident, and refugee.

Palestinian-Arab presence within this incorporation regime is situated within a continuous logic of exclusion specific to their civic status, effectively making their *bodies into borders*. They are included in the Israeli incorporation regime, yet they are perpetually consigned to its peripheries. Together, the racially hierarchical framework of the Israeli state apparatus and its juridico-political order determines that the borders of the state, its ideological and conceptual contours and the limits and ends of its representation and protection, all acquire their shape and meaning from the non-Jewish *other*.

In performing the boundaries of the State of Israel in various ways depending on the combination of the regimes of settler-colonialism, apartheid, and occupation to which they are faced, Palestinian citizens, residents, and refugees reproduce the sovereignty of the state. As such, their position relative to the state as Palestinians, regardless of their location and situation within its juridico-political order, remains on its margins.

Layered coloniality in Gaza

Similar to other nation-states, the nature of the State of Israel translates into the character of its juridico-political relations. The ideological, conceptual, and symbolic emphasis on its 'Jewish' and 'Zionist' character shapes the kind of membership it provides to non-Jewish persons, along with how this membership is formulated, structured, and arranged. This produces intense legal, political, socio-cultural, and economic exclusion within the Israeli regime, for non-Jewish political subjects, citizens, and refugees alike.[12] The multifaceted racialized frameworks of the State are embedded within a unitary Israeli incorporation regime, where relations and categories of inclusion and exclusion shaped by a settler-colonial ideology work in conjunction, intersect, and fuel one another. Key to this analysis is that, along with a *settler-colonial* logic of exclusion, the juridico-political system of the State of Israel also applies structures of *apartheid* and mechanisms of military *occupation*.[13] These interlaced political systems of oppression are activated according to various intensities depending on the placement of Palestinian subjects within the Israeli incorporation regime.

At almost 2 million, the Palestinian population in Gaza—whether residents who remained on their historical lands or refugees after the major displacements of the 1948 and 1967 wars and numerous Israeli army incursions since—all live under a military occupation shaped by settler-colonial objectives that mobilize apartheid policies. Over three decades, in tandem with the Madrid and Oslo negotiation processes, Gaza has been slowly isolated from the rest of Palestine and the outside world and subjected to repeated Israeli military incursions. These operations have reconfigured the biopolitical landscape of Gaza—one of the most densely populated areas on earth—giving shape to its surrounding borders today. Part of this biopolitical landscape has been the production of an enforced and expanding military no-go area—or 'buffer zone'—on the Palestinian side of the border. The territorial isolation of Gaza and its debilitating blockade have today resulted in total military control over their borders, land, airspace, sea, and monetary and business transactions.[14] Further, since 2007, the Gazan population has lived under a *de facto* government controlled by the Islamic Resistance Movement, *Hamas*. The result of this has been the suspension of direct foreign aid to Palestinians in the strip and an additional blockade sealing off its trade with the West Bank, travel to Egypt and Jordan, and links with the rest of the Mediterranean. This culminated in 2012

when the United Nations Country Team conducted a study forecasting the living conditions in Gaza by 2020. Looking at the human, infrastructural, and economic trends, the study held that in order for Gaza to be a livable place in 2020 accelerated "herculean efforts" will be needed in the sectors including health, energy, education, water and sanitation.[15] Later, in 2017—with the severe human loss and environmental destruction caused by the 2014 war—the UN Country Team further outlined the "de-development trajectory" for Gaza, reporting that life for the average Palestinian in Gaza is getting "more and more wretched."[16] With the start of the Great March of Return and the Breaking of the Siege on 30 March 2018, weekly civilian protests along the eastern border of Gaza resulted in targeted killings of protesting Palestinians, a great strain on Gazan health facilities, extensive damage to Gazan farmlands and livelihoods, and a tightening of the Israeli-imposed closure ensued.

Today, Palestinians find themselves living in that 'post-livable' Gaza. Electricity-related, water-related, infrastructural, and environmental crises have contributed to high population density and overcrowding, all of which is maintained by the ongoing Israeli blockade, repeated military attacks, daily army incursions and the imposition of an expanding buffer zone. In this context, the targeted environmental coloniality examined in this study—most recently in the form of aerial herbicides sprayed by the Israeli army—complements and exaggerates the staggering social and health-related crises in Gaza.[17] In the forthcoming chapters, this layered coloniality and the ways in which apartheid and occupation policies are activated in Gaza become visible when we observe the historical transformation of its agricultural lands, the forced transitions in cultivation practices adopted by Gazan farmers, and their relation to the stifled urban development of Palestinian cities within the strip.[18] Working from the relationship between political structures of control, military action, and the natural landscape, we look at the ways in which environmental violence is mobilized to enable a sovereign reorganization of Palestinian-Arab life. Far from an understanding of the environment as a passive landscape—or a mere setting for conflict—we consider how Israeli settler-colonial practices make use of environmental elements as an active tool of military warfare in and around the occupied Gaza Strip. In doing so, the study grounds ongoing Israeli military practices in Gaza in their capacity to inflict localized, social, economic, environmental, and human destruction.

Chapter 1

Reconfiguration of biopolitical landscapes in Palestine

> "If this is our land," remarked Friedrich sadly, "it has declined like our people."
>
> "Yes, it's pretty bad," agreed Kingscourt. "But much could be done here with afforestation, if half a million young giant cedars were planted—they shoot up like asparagus. This country needs nothing but water and shade to have a very great future."
>
> "And who is to bring water and shade here?"
>
> "The Jews!"
>
> —Theodor Herzl, *Altneuland*

Since the creation of the State of Israel in 1948, one year into the Palestinian Nakba, the occupied Gaza Strip has been isolated from the rest of Palestine and the outside world and subjected to repeated military incursions. Over time, the borders around Gaza have been hardened and heightened into a sophisticated system of under- and over-ground fences, forts and surveillance technologies, targeting its human and environmental infrastructures. Part of the violent reconfiguration of the material space has been the production of an enforced and expanding military buffer zone within the Gazan side of the border.

Today, Gaza is surrounded by three borders on land separating it from Israel and Egypt: to the north, it has a concrete wall with the Erez Crossing into Israel; to the south, it has a double wired-fence with the Rafah crossing into Egypt; and along its 40 kilometer eastern border with Israel—the subject of this investigation—it has a single-wired fence with watchtowers, followed by a 300-meter high-risk buffer zone with strong possibility of being injured and potentially killed by occupation snipers, and then a 1,000 meter risk-zone. The modification of the material and built landscape through practices of environmental warfare have thus reified Gaza as an enclave: divided and partitioned from the rest of the country.

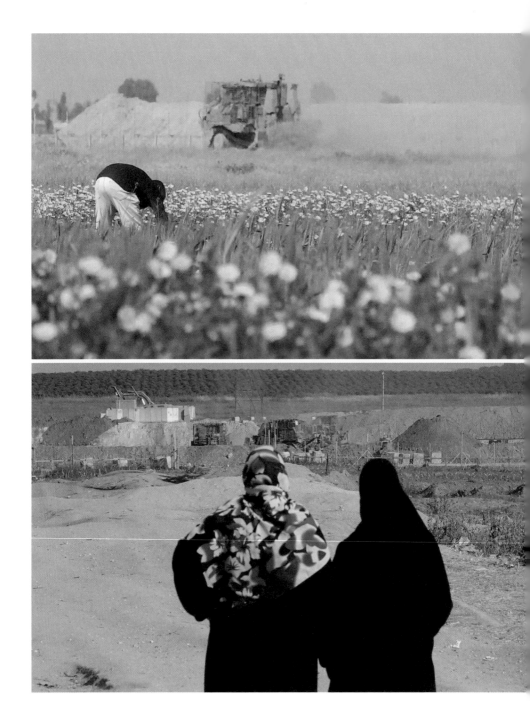

2. Still images from videos showing Palestinian farmers and residents watch as Israeli occupation bulldozers regularly flatten agricultural lands along the eastern perimeter of the Gaza Strip. Despite the obvious risks to their lives, farmers continue

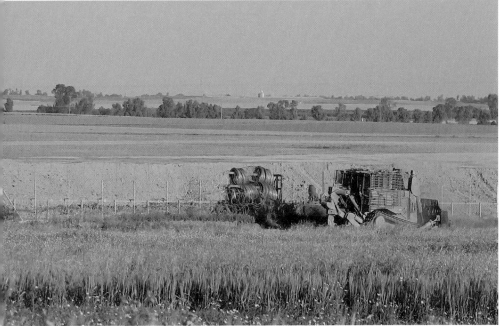

to harvest their lands to maintain their livelihood. In so doing they confront the hyper-militarization of the Palestinian landscape (Ain Media Gaza, 2018).

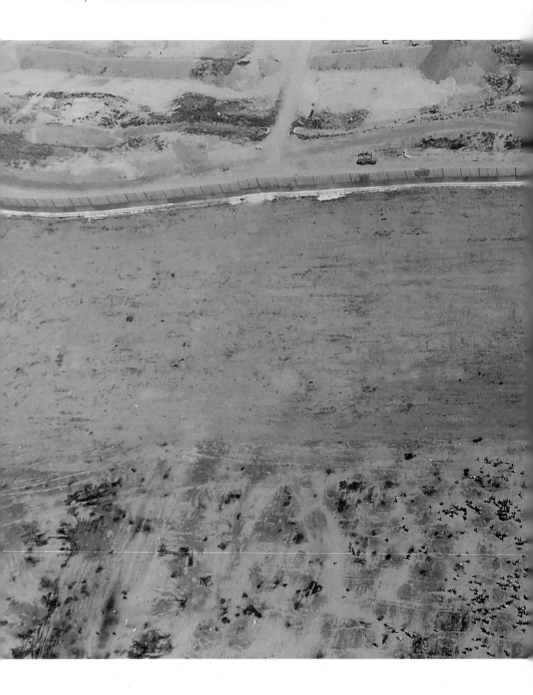

3. Still image from drone footage showing the flattened and scorched earth along the eastern perimeter of the Gaza Strip. These lands were formerly agricultural areas used to support the food security of the Palestinian population. Presently high-risk access-restricted areas, this terrain leads up to a fortified and surveilled fence separating Gaza from the rest of the country.

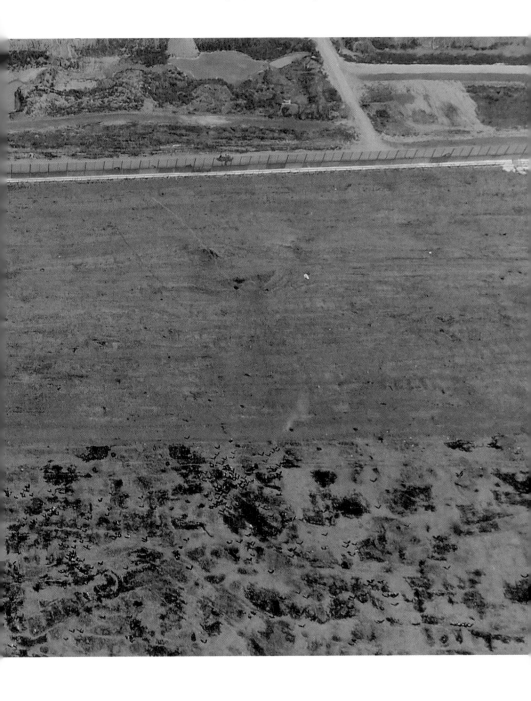

Formerly made up of lush citrus, olive, pomegranate, and fig trees—orchards that served as a continuous link between Gaza and the rest of Palestine—the historical production of the border area and the buffer zone also involves strict controls by the occupation army of agricultural and crop cultivation. Palestinian farmers living and working along the border are prohibited by the Israeli military from growing crops over one meter high, meaning that the cultivation of any trees in these areas is routinely destroyed, with farmers forced to transition and plant other low-growing crops. As an area that forms the future architecture of the besieged Gaza Strip, the agricultural lands along its eastern border perimeter are fundamental to the food security of the civilian population. Historic transformations between 1970 to 2014 have led to the gradual clearing of these precious agricultural areas in Gaza, and the present-day production of its eastern frontier. Over time, and through multifaceted practices of settler-colonial occupation, the conditions of agriculture were forced to collude with the conditions of security.

From August 1970 to December 1971, as head of the Israeli Occupation Forces (IOF) Southern Command, former Israeli Prime Minister Ariel Sharon launched the *Pacification of Gaza*, dividing Gaza into squares that could be isolated from one another by proceeding systematically, square by square, with search-and-destroy operations. For the first time, Gaza was completely sealed off with the construction of an 85-kilometer-long security fence with three points of entry: Erez, Rafah, and Nahal Oz. The immense brutality of this 16-month operation had lasting effects on Gaza and continues to shape the terrain of warfare on the besieged and occupied strip today. By September 2000, with the start of the mass popular uprisings of the Second *al-Aqsa Intifada*, severe Israeli restrictions on Palestinian access to land and sea were imposed. In this period, a buffer zone of 150 meters inside Gaza, known as 'access-restricted areas' (ARA), was first imposed by Israel.

In the over four sustained years of the *al-Aqsa Intifada*, Israel launched numerous named assault operations targeting Gaza, in addition to daily military incursions to maintain this buffer zone.[19] From October 2003 to January 2005, Israel launched eleven separate operations targeting Gaza exclusively.[20] The first four operations were aimed at the bulldozing of Palestinian residential areas and leveling of agricultural lands to establish the northern and southern borders of Gaza. Together, these named operations set the stage for Israel's unilateral withdrawal and gave shape to Gaza's eastern border with Israel today:

- *Operation Root Canal* (10–19 October 2003): Seizure and clearance of a strip of land 150 meters wide in Rafah along Egypt, with more than 300 Palestinian homes demolished or damaged to create an 'empty zone' along the border.

- *Operation Continuous History* (15 March–4 April 2004): More than 100 houses were demolished in Rafah with over 100 dunams[21] of land bulldozed.
- *Operation Rainbow* (13–24 May 2004): Ground assault and military operations bulldozing homes in southern Gaza with over 700 dunams of land leveled.
- *Operation Active Shield* (28 June–4 August 2004): Bulldozing operations in Beit Hanoun and Jabaliya widening the buffer zone and clearing around 3,900 dunams of land. Wide tracks of agricultural land were flattened to create an 8-kilometer empty zone between the towns.
- *Operation to Widen the North Gaza Buffer Zone* (8–11 September 2004): Bulldozing operations in northern Gaza continue in Beit Hanoun, Jabaliya, and Beit Lahiya leveling 90 dunams of land.
- *Operation Days of Penitence* (1–15 October 2004): Ground offensive in northern Gaza demolishing or severely damaging 195 homes and leveling 1,000 dunams of land.
- *Operation King's Court* (24–26 October 2004): Air and ground offensive reinforced by air strikes and pilotless drones to deter Palestinian rocket fire from Khan Younes, resulting in almost 30 homes demolished.
- *Operation Orange Iron* (17–18 December 2004): Military raid in Khan Younes demolishing 39 homes for allegedly providing cover for Palestinian rocket fire.
- *Operation Violet Iron* (22 December 2014–2 January 2015): Continued raids in Khan Younes to pacify Palestinian rocket fire on Jewish settlements in southern Gaza, resulting in 14 houses demolished and 41 heavily damaged.
- *Operation Autumn Wind* (2 January 2015).
- *Operation Eastern Step* (15–17 January 2005): Attacks on and around Gaza City with at least 80 dunams of land bulldozed.

Names like 'root canal,' 'continuities history,' 'penitence,' and 'rainbow' reveal the underlying colonial extermination fantasies that came with such military onslaughts—conjuring an image of erasure, violent extraction, and a 'justified' punishment against indigenous bodies. From 17 August to 12 September 2005, Israel unilaterally disengaged from Gaza, physically evacuating all Jewish settlers, demolishing settlement housing and infrastructure, as well as withdrawing Israeli soldiers from inside the besieged strip. This plan paradoxically stipulated that Gaza would be demilitarized, but that Israel would retain control over Gazan land passages, airspace, and territorial waters. On 18 September, one week after disengagement, the IOF continued its bulldozing operations to extend buffer zones inside the north of Gaza, preparing the terrain for an electric fence to run along its perimeter. And from December 2005, a new pattern of

open-ended military operations commenced by the IOF against Palestinians in Gaza—onslaughts that have consistently been repeated until today, and with rising intensities. These operations are aimed both at the suppression of Palestinian resistance and the deepening penetration of Israeli military 'buffer zones' placed within Gazan territory.

To name a few: launched on 28 June 2006, *Operation Summer Rains* was the first major ground operation in the Gaza Strip since disengagement and resulting in major human casualties. On the first day of this operation, the IOF bombed the only electrical power plant in the Gaza Strip, leading to water shortages and severe public health, safety, and environmental hazards. On 27 December 2008, the IOF launched *Operation Cast Lead* in Gaza resulting in over 1,400 Palestinians killed, the majority of them civilians, and 5,000 injured, and 13 Israeli soldiers were also killed, including three civilians. In addition to the massive infrastructural and devastating human cost of this 23-day military attack, wide areas of agricultural tracts of land were razed and bulldozed by the Israeli army both within Gaza and along the border, particularly in Rafah. On 23 May 2009, the IOF announced the expansion of its declared buffer zone from 150 to 300 meters along most of Gaza's eastern border, rendering more Palestinian agricultural land inaccessible. On 7 January 2010, the Israeli air force dropped leaflets over Gaza warning residents that they will be shot if they approach more than 300 meters to the eastern perimeter—these no-go-zones that place the southern villages of Abassan and Khuza'a within the prohibited area. On 14 November 2012, Israel launched *Operation Pillar of Defense* for eight days to confront the firing of rockets into Israel and smuggling tunnels on the Rafah border. This military attack resulted in 158 Palestinians killed, an estimated 60 percent of whom were civilians, with four Israeli civilians killed. As part of the 2012 ceasefire agreement, Israel agreed to reduce the buffer zone to 100 meters for farmers only. And from the end of 2009 until the middle of 2014, Israel's colonial siege of Gaza continued, with the prevention of all exports, except limited humanitarian imports, and most cross-border transit by individuals who did not fit into extreme medical cases, diplomats, and international NGO workers. Daily instances of live ammunition were used against civilians and Palestinian farmers working on land over 400 meters from the border perimeter and outside Israel's unilaterally declared no-go zone. Regular Israeli air strikes were also launched in this period on purported smuggling tunnels on the southern Rafah border and alongside Palestinian mortar firing.

Importantly, in this period, residential and agricultural areas along the northern and eastern borders of Gaza were regularly bulldozed with lands leveled and razed to clear lines of sight—a common occurrence justified by the occupation on military and security grounds. In these years, Palestinian civilians staged regular protests against Israel's imposition of a widening

buffer zone inside Gazan territory, along the border. These civilian protest actions were a precursor to the Great March of Return that was launched in 2018.

On 8 July 2014, the IOF launched *Operation Protective Edge*, a devastating military assault resulting in massive human, psychological, civil, infrastructural, and environmental destruction in Gaza. Nine days into this war, on 17 July, the operation transitioned from air strikes to a ground invasion of Gaza, beginning with heavy artillery shelling and incursions near the border to expand the buffer zone. Here Israel declared a 3-kilometer buffer zone all along and inside Gaza's borders. An area representing 44 percent of Gaza's territory, the expanded buffer zone during this operation placed the entire northern town of Beit Hanoun within it. Once expanded, the IOF began mobilizing the buffer zone to implement human, infrastructural, and agricultural destruction. Civilians and residents living within the zone were warned by the Israeli military to leave immediately or risk being bombed, and entire Gazan cities located along the eastern border—including Beit Hanoun, Shejaiya, Khuza'a, Khan Younes, and Rafah—were either completely or severely destroyed with rows of homes leveled to the ground and rendered uninhabitable.

In all these onslaughts, Palestinian agricultural areas along the border including both active crop and fallow fields suffered significant destruction due to systematic military razing, heavy vehicle tracking, bombing, shelling, and related clashes. International human rights organizations including UNRWA, *Human Rights Watch*, and *Oxfam* reported that the damage to Gaza's infrastructure from the 2014 operation was more severe than the destruction caused by either of the two major incursions that preceded it.[22] UNOSAT stated that "about 1,800 hectares of [Palestinian] agricultural fields have likely been razed or heavily damaged by these factors during combat operations," and with respect to environmental destruction, went on to report that:

> Agricultural areas were damaged by razing, as well as by convoys of heavy vehicles driving across them. Razing was *a focused effort* involving bulldozers or similar equipment and occurred throughout the Gaza Strip and especially in North Gaza and Gaza Governorates. In razed areas the topsoil was visibly scraped away by bulldozer blades in a back-and-forth pattern, resulting in a complete removal of the agricultural fields found at those locations. Heavy vehicle tracks also caused damage to agricultural areas as large numbers of armored vehicles transited the Gaza Strip, forming new road networks in the process. In some areas they were so common that they constituted a *de facto* razing of the agricultural fields.[23]

As Gaza's fourth major military conflict in eight short years, the 2014 operation was by far the most destructive for its already beleaguered agricultural sector. Additionally, on 28 October, Egyptian military forces began demolishing hundreds of Palestinian homes and buildings along the 13-kilometer border between Sinai and Gaza, creating a buffer zone as wide as 500 meters in some places. Later, on 17 November 2014, Egyptian officials announced that the width of this constructed buffer zone was to be doubled to 1,000 meters, and sometimes as wide as 2,000 meters in some areas.[24] Palestinian human rights organizations Al-Mezan and the Al-Haq Legal Center have together reported that the buffer zone has "led to the destruction of 35 percent of Gaza's agricultural lands," with a devastating impact on the crops, livestock and income of farmers, and on the food security of the broader civilian population.[25]

By January 2018, the IOF unveiled further plans for the construction of an underground wall along the entire eastern border with Gaza.[26] Until today, Israeli military incursions within Gaza along its eastern border continue against both civilians and Palestinian farmers working on their lands. At the time of writing, and launched on 7 October 2023, probably the most devastating Israeli onslaught on Gaza is ongoing with unprecedented human, infrastructural, environmental, psychological and communal destruction.

Engineered ecological realities

Destruction and control of environmental infrastructures has repeatedly moved from being a tactic of war or collateral damage, to an end in itself. Environmental infrastructural wars—operations that involved the systematic destruction of energy, sanitation, gas, oil, waste, and water supplies and systems—are increasingly applied in the Middle East and North Africa. According to Sowers et al.,

> The advent of infrastructural wars in the region can be traced to tactics and discourses employed by external and internal parties in prior conflicts in Iraq, Lebanon, and Gaza. In these instances, environmental infrastructures were repeatedly targeted through air campaigns by outside powers and attacks by internal factions, while long-term damage to environmental infrastructures was a signature feature of the sanctions regime on Iraq in the 1990s and the ongoing blockade of Gaza.[27]

These concerted changes in warfare scorch the earth in heightened ways. As environmental infrastructures are designed to mediate and funnel

the impact of human societies on nature, agriculture, and surrounding ecosystems, and maintain human security, their explicit targeting results in the inability of post-conflict societies to control and manage the damage to their environments, leaving colonial and imperial scars across generations.

Land is central to all settler-colonial formations, most centrally the ownership, domination, and management of it and its resources. Colonialism has been inextricably linked with eco-imaginaries and practices of cultivation—"of lands as well as that of bodies and minds through the imposition of a dominant (colonial, neo-colonial, modernist, and now neo-liberal) form of culture, one that was, and continues to be, deemed to be superior, more rational and enlightened, [and] of higher value."[28] Pushing the land to its full productive capacity is part and parcel of settler-colonial thinking. As outlined by post-colonial scholar Upamanyu Pablo Mukherjee, we ought therefore to understand "colonialisms and imperialisms, old and new, as a state of permanent war on the global environment."[29] This too is a key element of the unsustainability and instability of settler-colonialism as it relies in its essence on an insecure and obsessive imperative to optimize the productive capacities of land—all of which is predicated on the elimination of indigenous capacities.[30]

The long history of Western environmental imaginary views new lands as discrete and sharply delineated geographical and biological spaces, carrying with it medical and racial implications. An 'environmental imaginary' thus refers to a set of perspectives, ideas and identities that individuals and societies develop about a given landscape/space, which often involves a political narrative both about that environment and its inhabitants, including the processes through which how it was produced. Similar to the 'Orientalist' discourse described by Edward Said—a discourse aimed not merely at understanding, but also at producing and projecting an identity upon regions in opposition to a superior European self and building up bodies of knowledge and 'expertise' designed to study, discipline, and control it—Western environmental imaginaries involve the classification of colonized regions.

> Much of the early Western representation of the Middle East and North Africa environment, in fact, might be interpreted as a form of environmental orientalism in that the environment was narrated by those who became the imperial powers, primarily Britain and France, as a "strange and defective" environment compared to Europe's "normal and productive" environment. The consequent need to "improve," "restore," "normalize," or "repair" the environment provided powerful justifications for innumerable imperial projects, from building irrigation systems to reforestation activities to the bombing of "unruly" tribes to the sedentarization of nomads as a measure to prevent "overgrazing." [31]

Constructed regions, whether as tropical, temperate, or wild, were framed in imperial and environmental terms and deployed as an objective descriptor of singularized geographical spaces. As discrete and sharply delineated geographical, ecological, medical, and racial spaces, these regions were instrumentalized and hierarchized to reproduce relations of domination and control over indigenous communities through the production of a Western environmental imaginary. While viewing colonized regions richly endowed by nature, this imagination also professed an inability on the part of its local inhabitants to bring its potential development to fruition—a hindrance that became more concerning for Western thinkers of this tradition as indigenous populations seemed to resist all attempts by Europeans and North Americans at domination, settlement, and control over their lands and waters.

And yet, despite the emphasis on land, in the field of post-colonial studies, the notion of landscape remains largely absent.[32] Notions of space, belonging, and placehood replace the framework of 'landscape' as concepts less 'colonized' and weighted with the production of power and a Eurocentric gaze. While notions of 'space' and 'place' are more ambiguous and abstract, and perhaps also more flexible frameworks for understanding colonial legacies and imperial histories, they are nevertheless not immune from relations of power, erasure, and the production of an Other. In this study, the notion of landscape/space is particularly relevant both as a medium and framework for understanding colonial domination in Palestine. Landscape helps capture the forms in which nations and movements literally and figuratively 'construct' or 'produce' nature, engineering its appearance and infusing it with significations—rendering landscape a 'cultural practice' rather than a given fact.[33] Here landscape is both an object of investigation and a site of intervention; the very medium within which power and resistance are represented and conducted. Put differently, landscape is far from a neutral backdrop but is rather activated, serving as the medium of violence. Dispossession, deforestation, planting, land-grabbing, and acquisitions, privatization, re-modeling, clearance, or the destruction of infrastructures of life, including food sources, buildings, or supplies, all mobilize the landscape in their domination.

Representations of Middle Eastern and North African landscapes nearly invariably include desolate scenes of endless empty and parched deserts, decorated perhaps with an isolated string of camels, or a beach with large mounds of golden sand, a minaret, or an oil tower in the background. The temporality and general impression of these landscapes is slow, hazy, and dizzying, as if they are waiting for 'activation' by someone or something outside of it. Whether reproduced in academic scholarship, literature, film, tourist advertisements, or news media, these imagined colonial representations of the region's landscape place the environment centrally within them, projecting an understanding of the Middle East and North

Africa as marginal, on the edge of ecological viability or as a degraded landscape facing imminent disaster due to human inaction.[34] With this, an environmental imaginary enabled storytelling that pushed forward imperial interests in the name of 'development' and, later, of environmental 'sustainability' and 'protection.' In the case of the constructed 'Middle East,' as Diana K. Davis explains,

> Deforestation narratives have been particularly strong in the Levant region since the nineteenth century, where some of the most emotional accounts of forest destruction have hinged on the presumed widespread destruction of the Lebanese cedar forests illustrated in the cover image by Louis-François Cassas. Similar narratives of overgrazing and desertification were used during the British Mandate in Palestine to justify forestry policies as well as laws aimed at controlling nomads, such as the 1942 Bedouin control ordinance, in the name of curbing overgrazing. Such environmental imaginaries, once constructed, can be extremely tenacious and have surprisingly widespread effects.[35]

In Palestine, the construction of an 'Israeli landscape' to redeem the purported damage done to the land by its indigenous population commenced with the first Zionist settlers in the nineteenth century and intensified with the establishment of the State of Israel in 1948. Reflected in former Prime Minister David Ben Gurion's 1951 public address to the newly formed Israeli Knesset (Parliament):

> We must wrap all the mountains of the country and their slopes in trees, all the hills and stony lands that will not succeed in agriculture, the dunes of the coastal valley, the dry lands of the Negev to the east and south of Baer Sheva, that is to say all of the land of Edom and the Arava until Eilat. We must also plant for security reasons, along all the borders, along all the roads, routes, and paths, around public and military buildings and facilities [...] We will not be faithful to one of the two central goals of the state—making the wilderness bloom—if we make do with only the needs of the hour [...] We are a state at the beginning of repairing the corruption of generations, corruption which was done to the nation and corruption which was done to the land.[36]

This 'Israeli landscape' was largely cultivated through the multifaceted and by now well-documented[37] eco-colonial practices of the quasi-governmental Israeli organization, *Keren Kayemet L'Yisrael*, the *Jewish National Fund* (JNF), which has since made striking efforts to position Israel as an environmental

pioneer.[38] Established in 1901, the JNF may very well be the first transnational environmental nationalist NGO, seeking to 'make the desert bloom' by planting forests, natural reserves, and recreational parks over the ruins of Palestinian villages, holy places, and historical sites. Distinguishing itself from other transnational Zionist organizations, such as the *World Zionist Organization* and the *Jewish Agency*, the JNF has since its inception portrayed itself as an environment-oriented nationalist organization, supporting the 'redemption' and 'reclamation' of the land through colonial policies presented in the language of preservation, maintenance, protection, and development of vital ecosystems and ecologically sound environments. Indeed, its public-facing promotional materials boast proudly that "Israel is the only country in the world that entered the twenty-first century with a net gain in the number of trees"[39]—without context, of course, of the ways in which trees and the 'greened' landscape in the country are mobilized as weapons of erasure as part of a colonial imaginary that naturalizes non-Palestinian presence.

To highlight the links between landscape and colonial eco-imaginaries in Palestine, scholars have looked at the role of forests, and particularly the placement of trees in the formation of national identities and collective memories. As politicized entities, trees embody national ways of life, featuring regularly as a symbol of national identity and rootedness. Whether the English oak, Japanese cherry blossom, Canadian maple leaf, or the Lebanese cedar, trees, and the landscapes they create, often propel an ideological desire to physically alter a terrain to protect or maintain parts of national significance—making it appear as a "given and inevitable" natural reality and concealing its politically engineered origin.[40] Landscapes create a sense of belonging among a people, producing their presence in the land as a natural fact, while excluding those rendered outside. In this manner, the eco-imaginary in Palestine has become a terrain of colonial struggle through the mobilizing of species of trees that reflect lived significances and collective memories: the pine within the Jewish national consciousness and the olive in the Palestinian. Indeed, the JNF's preference for European-looking pine is not surprising given the historical matrix of European colonialism within which the Zionist movement emerged. Cultivating trees that conform to the picturesque Western ecological sensibilities further demonstrates Israel's European-style environmental values, while also pushing forward a new historical narrative on the landscape that naturalizes a more 'civilized' colonial presence. And so, as a settler-colonial project, widespread afforestation of Palestinian orange and olive orchards across the country enabled the State of Israel to weaponize forests to erase Palestinian presence in strategically important spaces, providing camouflage for military objectives.[41]

Chapter 2

The disappearing trees of Gaza

I passed by a vineyard and saw with one eye,
How a Jew and an Arab were sharing a pie
The Jew took some pie crust and gravy and meat
While his friend had the dish as his share of the treat.

When the pie was all finished the Jews as a boon
Permitted the Arab to pocket the spoon
Then some Englishmen came to join in the meal
But they ate the orange—and left them the *peel*!

—Mustard and Cress (P.E.F. Cressall),
Palestine Parodies Being the Holy Land in Verse and Worse (1938)

Mention of citrus in Palestine inevitably conjures up the oranges of Jaffa: large and aromatic ovular-shaped oranges with thick-skin and an exceptionally sweet taste. Reference to the groves in and around the Jaffa area in the modern era go as far back as Napoleon during his siege on the city in 1799, while on his voyage to Egypt, the Middle East, and Asia. In 1870, 'Jaffa' was first used as a brand by an export firm owned by members of a German Christian society, the Templars, who settled in Palestine and pushed forward export of the fruit to produce its global fame. When exported, oranges were sent via sailboats from the Jaffa port to cities including Alexandria, Beirut, and Constantinople—finding their way to the aristocratic tables of Western Europe and the dining rooms of upper classes in the United Kingdom to later form the international reputation of the Jaffa orange. Named locally in the middle of the nineteenth century as the *Shamouti* orange by citrus grower Anton Ayoub, citrus cultivation required greater material and financial investments than other agricultural goods.[42]

Compared to other fruit-bearing orchards at the time, such as almonds, figs, and vineyards, citrus took longer for the trees to bear fruit, more water was required for cultivation, irrigation, and fertilization, and more space was required for the preparation of the land for orange trees.[43] In Palestine, local citrus industry was overseen and owned by Arabs until the end of the nineteenth century and while the concentration of Arab citriculture was in Jaffa, other cities such as Tulkarem, Beit Hanoun, Acca, and Gaza also participated in the planting of citrus groves. Control over the industry was existential to these cities, affecting the entire social fabric surrounding the

community, including the development of business ties both domestic and international, control over the land, its infrastructure and development, and the formation of labor relations which forged local friendships and networks over generations of workers. The citrus industry facilitated communal links across religious segments of the communities in these cities, it brought investors and inspired migration of families in search of labor and income. Citrus formed the livelihoods and sustenance of families and inspired urban growth. In this sense, citriculture was exactly that—a *culture* that formed social behaviors, norms, and customs with a major economic and social role in the lives of the Arabs living under the Ottoman Empire and later British Mandate in Palestine. The social mobility, modernization, and fast-growing infrastructural growth experienced by numerous Palestinian-Arab villages until the *Nakba* was heavily indebted to the citrus industry.

By the beginning of the twentieth century, Jewish entrepreneurs began their engagement in the citrus industry and "on the eve of World War II, the citrus industry of Palestine was almost evenly divided between the two national sectors of which it consisted, the Palestinian and the Zionist sectors [...] both in terms of planted acreage and of volume of export."[44] Once the Zionist *moshavot* (rural Jewish settlements during the Ottoman period) entered the playing field, it relied heavily on the Arab sector for local knowledge, direction and development. In *The Lost Orchard*, authors Mustafa Kabha and Nahum Karlinsky explain that much of the manual labor, including manual cultivation, harvesting, packing the fruit with skill and efficiency without the use of mechanization in most Jewish-owned citrus groves until World War I, was overwhelmingly dependent on Arab labor and expertise—including its export and marketing abroad to Western Europe and the United Kingdom.[45] They go on to point out that:

> While socialist, Marxist, and communist worldviews greatly affected the Zionist community in pre-1948 Palestine, up until 1948 the Jewish citrus industry was overwhelmingly composed of market-oriented Jewish practitioners and nonsocialist entrepreneurs. Likewise, socialist and communist ideas had only marginally penetrated Palestinian-Arab society prior to the *Nakba*. Hence, the Palestinian "Men of Capital," as Sherene Seikaly characterized them, and the Jewish citrus growers shared a common economic *Weltanschauung* that favored a capitalist economy over a socialist one. At the same time, most Arab and Jewish practitioners also desired to strengthen the economy of their respective communities. Evidently, this ideology of economic nationalism contradicted the citrus entrepreneurs' market-oriented *Weltanschauung*. However, the economic structure of the industry eventually forced the two parties to reach some cooperation.[46]

Entry of Jewish entrepreneurs into the citrus industry inevitably led to the rise of a similar citriculture in the Jewish community in Palestine— particularly in and around Jaffa as the center of orange production. Over time, the orange was adopted as a symbol of connection to the land through cultivation, and the industry itself propelled the establishment of Jewish settlement and social labor relations in the country. Historian Amnon Raz-Krakotzin explains how the Zionist movement mobilized the modernization and the cultivation of the citrus fruit as part of its building of a national consciousness among the Jewish community in Palestine. Colonial orange iconography helped convey an eco-imagery of a backward and uncivilized Arab-Palestinian society, with domination over the industry and Jewish development of knowledge and expertise on the cultivation of the fruit reflecting broader control over the land.

While at the initial period of Zionist colonization before World War I the national consciousness of both Jewish- and Arab-Palestinians was yet to reach its maturity, the ideology of separation and erasure did eventually dominate the dynamics of social relations in the country with the launch of the British Mandate, replacing the ethos of cooperation. A microcosm of the larger history of Palestine and the lived experience of Palestinians, what started as a largely private Arab enterprise in the mid-nineteenth century, the citrus industry suffered both with the dwindling political power and socio-economic conditions of Arab society as well as the losses over control of the land due to Ottoman rule, British control, and Zionist colonization.

> In its first year World War II caused a sharp drop in citrus exports, and by its second year all citrus exports ceased. Commercial sailing in the Mediterranean became extremely dangerous, ships were converted for war purposes, Europe's gates were closed, and the large UK market became a war economy. Not only were plantings completely halted due to a lack of resources for the routine cultivation of groves, their irrigation, and picking of fruit, but also the quality of work in the groves diminished significantly, and many of the groves were neglected. The entire industry entered a very long period of continuous losses. [...] Whereas in 1939 production per grove in the countrywide industry was sixty to seventy-five export cases of oranges per dunam, by 1945 it had dropped to twenty-four cases per dunam.[47]

The importance of the citrus industry, of its maintenance and control for a future Jewish State became evident when in late 1948, Israel's newly established transition government initiated a Census of Arab Citrus Groves that it had occupied during the war. Like Palestinian property, citrus groves that came under Israeli control were legally defined as 'abandoned' in that

they were owned by Palestinians who had become internally displaced or refugees and therefore, had 'abandoned' their lands according to Israel.[48] Kabha and Karlinsky explain that,

> The census, called the "Census of Arab Citrus Groves" (1948), was conducted with a double intention: to gain information regarding claims of Palestinian grove owners demanding the return of their assets and to classify groves into those that could be immediately cultivated and those that could not.[49]

What became evident was the abysmal situation of Arab citrus growers who would not only have lost around 85 percent of their citrus land to be placed under Jewish control under the proposed 1947 United Nations Partition Plan, but instead had most of their citrus lands transferred to Jewish control with most of the industry's leadership becoming refugees, refused the right to return to their original lands. Scholars have further documented that even the Arab citrus owners who were given involuntary Israeli citizenship after the state's establishment in May 1948, and legally categorized as 'present absentees' were also forbidden from reclaiming their citrus orchards and property.[50]

Eco-colonial imaginary of Gaza

In the story of the orange in Palestine, the placement of the citrus fruit in the formation of Gazan identity, including local knowledge production, socio-economic relations and migration patterns, domestic and international cultural exchange, and the ongoing maintenance of Israeli colonial eco-imaginaries is largely understudied. Much iconography exists likening the oranges of Jaffa to nation-building; whether produced by the Zionist movement to claim the land or by the Palestinian liberation movement as part of their resistance and Right of Return to their lands. Almost all Palestinian political groups, including *Fatah*, the *Popular Front for the* Liberation of Palestine, and the Democratic Front for the Liberation of Palestine mobilized the orange as part of their annual commemorations of key moments of their resistance, such as *Land Day* on 30 March, *Prisoner's Day* on 17 April, the *Nakba* on 15 May, and *International Woman's Day* on 8 March.[51]

But iconography linking Gaza with the orange, its production and symbolism is less available—as is scholarship about the link between the identity of Gaza and citrus production. Of course, what is considered 'Gazan identity' today packages as a single unit the local practices and unique character of its various cities, including, Beit Lahiya, Beit Hanoun, Shejaiyeh, Khan Younes, Deir el Balah, Rafah, and others, given the colonial

label of the 'Gaza Strip.' But importantly citrus cultivation and industry was significant in the identity production of Palestinian society in Gaza City and Beit Hanoun in particular, including other neighboring villages. Indeed, the citrus orchards in the Gaza district grew northward along the coastline all the way to Jaffa, encompassing a single shared landscape. Gazan orchards were spread beyond the hyper-militarized delimitations of its present-day imposed 'borders,' linking its ecology and communities to villages and practices of exchange in the rest of Palestine, and the world.

The geographical distribution of Arab citriculture was based on the availability of groundwater for irrigation and the ability to transport produce from the orchards to the port for export. And although the Jaffa port was the main site of export, the district of Gaza was particularly active in citrus production given its relatively accessible groundwater as well as its active port for regional and international export. Like Jaffa, proximity to the port was a central consideration in calculating the costs of investment in the Gazan citrus industry and a key element in determining the concentration of Arab-led citriculture in the Gaza area. It would be an understatement to say that the landscape around Gaza has experienced dramatic changes over the past decades. Before the *Nakba*, Gaza was a smaller sub-district— Jewish settlements were erected in the Gaza area only in the mid-1940s, and the Partition Plan had planned for Gaza to be the central part of a future Arab state. Of the over two-thirds of the area specified as the Gaza-Beer el-Saaba district in the UN plan, agricultural areas owned by Gazan farmers in the north that produced citrus, and vegetables were lost. Largely rural in its original character, the influx of refugees to the strip resulted in rapid and uneven urbanization, with a small percentage of large-scale landowners. These indigenous residents and families had mostly invested in citrus in the first decades after the *Nakba* and dominated Gaza economically and politically.

4. Archival maps from 1931, 1943, and 1946–1948 collected by the Palestine Exploration Fund showing historical citrus production in and around the occupied Gaza Strip. Despite the inaccuracies and ambiguities that come with cartographic reproductions of lived spaces, these maps show how citrus and olive orchards formed the dominant landscape in Palestinian villages, giving shape to the social fabric of Palestinian communities (Palestine Exploration Fund).

Colonial erasure of citriculture in Gaza

After the *Nakba*, while Arab-owned orchards in fell under Zionist control in major industry cities like Jaffa, most of the citrus land in the Gaza district, which was relegated to Egyptian control, remained in Palestinian hands until much later. Examining the conditions that fueled the transition away from citrus production requires examining the ongoing Israeli colonization of Gaza's natural resources that supplant and suppress traditional modes of relating to the land. The colonial harm inflicted on the ecology of the Gaza district and its cities can be traced through the disappearing citrus orchards and the forceful transition to other types and practices of cultivation. In this manner, the fate of the orange groves—and perhaps we can even claim trees in general—serve as 'bio-indicators' and 'silent witnesses' to Israeli eco-colonial violence.

During the 19 years of Egyptian rule, the Gazan economy was unable to fully develop to support the needs of its residents, and as such the large incoming refugee population relied mostly on low-paying seasonal jobs in the citrus industry. In these years, citrus production was the only growth sector with profits funneled mostly to the more middle and upper classes of indigenous residents of Gaza. While in 1948 citrus production occupied around 6,000 dunams in the Gaza district, by 1966, just prior to Israeli occupation, it had extended to 70,800 dunams.[52] Once occupied, Gaza suffered almost immediate economic and agricultural loss. Egyptian employment and markets were cut off and Gazan production and labor was redirected through colonial policies to acquire significant dependency on and integration within Israeli markets.

> There was a somewhat similar shift in exports: in 1968, 28 percent of Gaza's exports went to Israel and 18 percent to Jordan, the balance continuing to go to Eastern Europe in fulfillment of pre-1967 citrus contracts. A decade later the shift in trading patterns was even more pronounced. Two-thirds of Gaza's exports went to Israel, 26 percent to Jordan, and 7 percent to other countries, the contracts with Eastern Europe having ended by 1975. In contrast, 91 percent of imports came from Israel, and nothing was imported from Jordan or Egypt. Citrus exported to Jordan was sold as fresh fruit, whereas most of the citrus sold to Israel was used for canning and juices. Dates, strawberries, and vegetables were also sold to Israel, and local industries engaged in subcontracting for Israeli firms.[53]

Along with the major shift in the Gazan economy, its agricultural identity was similarly restructured after the Israeli occupation took hold. Gazan farmers were prevented by Israeli policymakers from producing items that would compete with Israeli goods, which meant that restrictions were imposed on the cultivation of particular produce. As a result, "melons, onions, grapes, almonds, olives, and fish has decreased" and Gazan farmers found themselves within a permit regime for planting vegetables, fruits and, in particular, trees.[54]

> Particular pressure has been placed on the citrus sector, which provided 70 percent of the Strip's agricultural exports and 55 percent of the value of agricultural production. Acreage for oranges, lemons, tangerines, and grapefruit remained constant... and the Israeli government has virtually never issued permits for farmers to plant new trees, even to replace old, nonproductive trees. Farmers had planted many new trees in the early 1960s, and so citrus yields peaked in 1975–76 at 237,100 tons [...] But at least 500 acres of old trees had to be uprooted by 1980, and the yield of other trees began to drop.[55]

In this fateful period, the landscape of Gazan agriculture was actively redirected by the Israeli occupation toward the focused production of specialized crops. Farmers, particularly those in Beit Lahiya, were instructed by their colonial administrators to grow strawberries so as not to be prevented from using their lands. Shipped through the post of Ashkelon through the agricultural export cooperative, Agrexco, Gazan strawberries were sent abroad using Israeli marketing channels to avoid administrative, bureaucratic, and security delays as well as higher transportation costs. Taken together, colonial administration in Gaza transitioned its agriculture from near-total dominance of the citrus industry to the introduction and production of other fruits and vegetables with an eye for export.

These engineered colonial transitions in the first decades of Israeli occupation marked a path of agricultural priorities in Gaza, causing a decline in the quantity and quality of its historic citrus industry. Forced changes in production along Gaza's engineered and encroaching peripheries contribute to the magnitude of harm done to the ecology along the 'border' with Israel. Today, ecological destruction along the ARA, including the uprooting and bulldozing of the key agricultural infrastructure such as wells, greenhouses and irrigation instruments that existed are also part of the story of forced transitions in cultivation in Gaza. Today, like the citrus groves of Jaffa, Acca, and Tulkarem that preceded it, Gaza's orchards are disappearing due to several key factors, many of which were central to the historical successes of the citrus industry in and around the present-day besieged strip. To begin

with the *water* in the occupied Gaza Strip is largely saline water, heavily rejected by citrus trees. The quality of water is key to producing citrus, but rather than having 1 dunam of land with an output of 5 to 10 tons of citrus production in one harvest season, insufficient access to clean water for Palestinian farmers reduces production to only 1 to 2 tons. Over time, and with deteriorating local Palestinian infrastructure under Israeli control, the lack of sufficient output prevents Arab citrus farmers from maintaining their livelihoods.

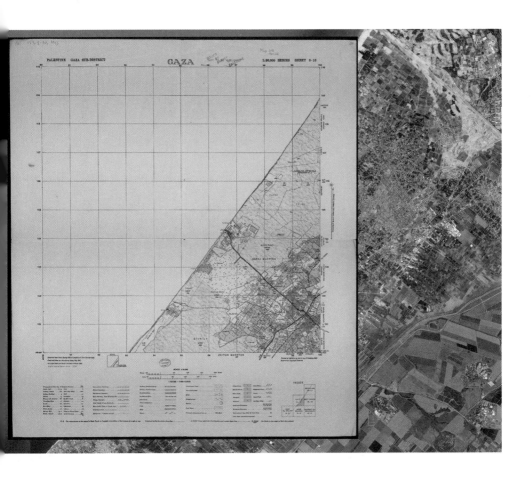

5. Composite map overlaying present-day Gaza City onto a historical map of Gaza from 1943 with the orchards that surrounded it showing the heightened and engineered density and suffocated urbanism resulting from the Israeli-imposed siege and occupation. Assisted by Ariel Caine. (Palestine Exploration Fund).

The second and obvious major impediment to the citrus industry in Gaza is a lack of *space*. Citrus orchards require large open spaces. An ongoing colonial process of land confiscation in which Palestinian farmland in Gaza is transitioned into impossible spaces of access, whether through militarized ad restricted areas and the adjacent construction of Jewish-only settlements is a root cause of its disappearing citrus orchards. Former Palestinian-controlled lush orchards rendered off-limits to its owners with guard towers, double wired metal fences, and concrete walls and other similar architectures of confinement serving as impassible partitions on the landscape. Until 2005, during the time of Israeli settlements, there were no space for the orchards, and with the expansion of these Jewish-only neighborhoods many Palestinian farmers had to uproot their own orchards so that they could live on the land itself. Several farms needed to be cut and destroyed in order to make space for housing and other basic civilian infrastructure to serve the occupied Palestinian population. As such, around 30–40 percent of the orchards in Gaza were uprooted by Gazan farmers themselves; a difficult and painful ordeal for these families given that the successful re-cultivation of citrus fields is extremely straining. Further, once the settlements were evacuated by the Israeli occupation, the damage done to the land from the construction was, in most cases, too extensive for the rehabilitation of pre-existing citrus orchards and other vegetation. By the time the settlements were removed and emptied there was a lot of zoning and planning needed to rebuild the orchards. To this end, in the immediate years following the removal of the Israeli settlements, the local authorities produced around 2 million of mainly olive trees, smaller trees, and gave them as gifts to Gazan farmers to plant.

Relatedly, Palestinian *access* to the land also deserves unpacking. The oldest and largest orchards mainly located in Gaza's north-eastern peripheries are today practically erased and part of the Israeli-imposed 'buffer zone.' Located in one of the most militarized areas of the Gaza Strip, these orchards are inaccessible to farmers who are left only observing their fields but unable to harvest them without risking their lives. Indeed, during the IOF's repeated incursions in Gaza, a regular part of the military operation involves the cutting of hundreds of trees, especially in the orchards in Beit Hanoun closer to the perimeter. For example, according to the Gazan MOA, in 2006 there was as much as 130,000 dunams of agricultural land in the strip, but by 2011, in the course of five short years and three major Israeli attacks, one found only 90,000 dunams of land that remained viable and accessible for agricultural use. The IOF had flattened all of these areas, uprooted the orchards, and particularly in the case of Beit Hanoun, went in even deeper into Gaza beyond the buffer zone to create this landscape. Cutting access for Palestinian farmers, the eco-occupation of Gaza therefore extends beyond moments of spectacular destruction of agriculture toward

the regular surveillance and monitoring of Palestinian land use in a manner that renders it off-limits.

Successive wars in Gaza and political instability have also torn the social fabric of Palestinian communities in the strip. The *displacement* and re-displacement of Palestinians has caused a blow to traditional family structures. Whereas large families in the past would remain mostly in one area over decades and cultivate the land collectively, constant Israeli military incursions and displacement has prompted children in larger families to move to other areas as adults and take assets for a part of the land to live on for their own families. With this displacement, each member of the family would receive a small part of the land thereby rendering them unable to get income from citrus cultivation as production from smaller orchards is insufficient for it to be financially sustainable. This is part of the reason why many Palestinian citrus farmers in Gaza whose family members remained on their historic family land were nevertheless obliged to transition their crops to other fruits, such as strawberries, eggplants, and watermelon.

The location of the historic citrus orchards in Gaza, away from the sea in cities like Beit Hanoun, but also largely in agricultural lands adjacent to the present-day Israeli-enforced buffer zone served as a hindrance to the military objectives of the occupation. According to the World Food Programme of the United Nations Office for the Coordination of Humanitarian Affairs in a 2010 special focus report, the IOF prevent and systematically target any cultivation of crops over 80 centimeters high along the ARA.[56] By 2018, the *Al-Mezan Center for Human Rights* reported that, according to farmers, the razing activities of the Israeli occupation forces in the eastern border area have forced them to plant crops no taller than 40 centimeters.[57] The objective, to maintain optimal security visibility and surveillance of the 'border' area, is also a central reason for which crop-killing herbicides were sprayed by the Israeli army along this terrain. Maintaining a flat landscape without trees, prevents Palestinian resistance fighters from mobilizing a terrain of relative invisibility as part of their confrontation with the occupation, and—as further discussed in the Conclusion—enables the occupation forces to exercise power against Palestinians from a distance. A kind of flattened, horizontal panopticon, the entire restricted 'border' area is rendered a space of permanent visibility, inducing a state of conscious observation among colonized subjects. In the case of the Wadhan family in Beit Hanoun, their homes and citrus orchards were near the encroaching Israeli 'buffer zone.' In periods of conflict, resistance fighters would use the Wadhan orchards as cover from the Israeli army. As a result, their orchard, and in many cases also their family home, became a literal battlefield with repeated shelling and strategic activation by armed forces.

The temporality of citrus production played another factor in its slow and engineered erasure in and around Gaza. Unlike other faster-growing crops, citrus trees need constant care, with longer production cycles that can take years before they are ready for harvest once (re)planted. One farmer recounted to me that they tried to save the citrus orchards but they "needed to find enough days of peace" for the replanting. With snowballing Israeli onslaughts in Gaza from major wars in 2006, 2008–2009, 2012, 2014, 2018, and 2021--waach with increasing degrees of destruction culminating in the 2023 attacks--to daily incursions and bulldozing practices, there have not been enough cumulative periods of stability for Palestinian farmers to replant the orchards. This too, the temporality of eco-colonial violence, is part and parcel of the forced transition to planting faster-yielding produce.

In my conversations with farmers, the erasure of the citriculture in Gaza was felt in unison with the colonial rupture to Gaza's historical links with the Mediterranean and the region more broadly. Farmers would repeatedly recount that, in the past, they would send oranges to Jordan, Iran and to numerous countries in the Gulf. Yet after import and export closures, especially the closure of the Eretz crossing, it became impossible for farmers to maintain a living off of citrus production, needing also to import clean water and fertilizers to make the citrus groves manageable, and to export their produce on time to prevent rotting of the fruit in transit. Today, Egypt and Turkey, among other countries in the region, have also started to export citrus to the same customers Gazan farmers used to have in Europe and the region, and with far more stable production.

Shallow roots: From the orange to the strawberry

Israeli companies had begun exporting citrus to Europe and since citrus orchards required greater labor and water, it was more economically sound for Israel to have produce like strawberries grown in Gaza. As explained, for this reason, many Gazan farmers were compelled by Israeli occupation authorities to transition to strawberry production, among other faster-growing and more economical fruits. Strawberries started to be planted more systematically in Gaza in the early to mid-1970s with an eye to its susceptibility to the local climate, soil, and irrigation water. In these years, strawberry was mainly planted in Beit Lahiya and northern Gaza where water and softer sandy soil is more readily available. With the arrival of the Palestinian Authority in, 1993, the crop was increasingly grown throughout the strip including in Khan Yunes, Rafah, and the Al-Mawasi area. As a result, existing citrus orchards in present-day Gaza remain largely in and around Beit Hanoun and Gaza City but they are no longer a profitable industry. During the citrus season, from November to around May, Gaza has citrus such as lemon, orange, pomelo,

and grapefruit imported mainly from Israeli farms as local production is not able to remain competitive in the citrus market.

Today, strawberries have replaced much of the citrus and olive trees in the strip, and despite the relatively small area of farmland used for this sector, it enjoys high economic and social value. In all of the ways that citrus cultivation has been targeted, as a crop, strawberries seem designed to survive Israel's eco-colonial practices. Strawberries are able to survive on partially saline water, they have faster production cycles, are easier to cultivate and replant after destruction and uprooting, are more mobile after moments of displacement, require less space and distance between each planted crop, and enable farmers in Gaza's northern peripheries and along the buffer zones to remain visible to the observing Israeli occupation forces. As a crop, with limited historical roots in the country it adapts well and is highly versatile. The use of compost for the cultivation of strawberries enables significant increase in fruit productivity, saving Gazan farmers the use of precious water supplies and decreasing its need for the use of fertilizers.

Despite this, the conditions of Gaza's ongoing colonial isolation and erasure make it increasingly impossible for farmers to sustain their livelihoods off of the land, even with strawberry production. In today's Gaza, as the agricultural export industry is fully reliant on the Israeli permit system, strawberries are slowly being replaced with other low-growing, fast-yielding, cost-effective and high-demand fruits and vegetables. Indeed, as a colleague at the *Union of Agricultural Work Committees*, the largest agricultural development institution in Palestine, told me during my time in Gaza, the most recent crop to slowly begin its replacement of strawberries in this line of forced colonial transition is pineapple—with the first pineapple farm planted in Khan Younes in 2017.

Examining the conditions that make strawberry production more practical and fuel the transition from citrus production requires examining the ongoing Israeli colonization of natural resources that supplant and suppress traditional modes of relating to nature. Witnesses of Israeli neo-colonial violence, the disappearing orchards in Gaza mark its new disconnected reality. The transition from the orange to the strawberry—and perhaps later to pineapple—is more than a shift in markets and produce. They affect the history and *identity* of Palestinians in Gaza. The links between cultivation and national or communal identity are well-known and documented in other contexts, including their intersection with colonial nation-branding. But in the context of aggressive climate change the instabilities, tensions, and erasures that come with transitions in vegetation are growing increasingly stark. For example, in the case of the Swiss canton of Valais, global heating has resulted in the growth of cacti, *Opuntia*, or prickly pears, that are proliferating on the mountainsides of the canton, encroaching on natural reserves and

causing a biodiversity threat.[58] Used to "seeing their mountainsides covered with snow in winter and edelweiss flowers in summer" warmer and drier temperatures have given way to what is named in media coverage as an 'invasive species colonizing the slopes.' Launching an uprooting campaign in 2022, the press release stressed that "this invasive and non-native plant is not welcome in the perimeter of prairies and dry pastures of national importance."[59] Evidently the discourse mobilized is dominated by aggressive language of aliens and invasion, which contributes to the use of violent and war-like metaphors to push for pre-emptive and combative control. In the Gazan case the transition, as well as local responses to it, are less pronounced and weeded through long-term colonial policies imposed by the occupation. That said, the transition to strawberry cultivation nevertheless carries a similar ecological, cultural, and socio-political impact. In place of the orange, the strawberry is surfacing as the symbol of Gaza, redrawing the boundaries of the identity of its besieged inhabitants. Whereas in the past the orange was a continuous link between Gaza and the rest of historic Palestine, with deep generational roots and a symbol of steadfast and continuous presence, the abrupt transition from oranges to strawberries distances Gaza from the constructed identity and vegetal knowledge production of Palestinian farmers elsewhere. Put differently, this symbolic and political transition at the level of fruit production can be seen as another mechanism through which Israeli neo-colonial violence reifies Gaza as an enclave: divided and partitioned from the rest of Palestine. And yet, today, while iconography of Gazan oranges is less available, remnants of the central placement of the orange in the identity of Gaza remain visually inscribed on its streets. The streets of cities throughout the occupied Gaza Strip are riddled with the images of orange and olive trees.

With recurring themes of resistance, remembrance, loss, and return the graffiti, murals, and paintings on the walls of Gaza span from the sides of buildings in working- to middle-class neighborhoods, to the walls of refugee camps, universities, hospitals, and shopping complexes. As expected with nationalist iconography, these images are often gendered and feminized, emphasizing the role of women in preserving culture, education through oral history, cultivation of the land, and birthing the nation—all while interlaced with the orange, the olive, the tree, and the land itself. These images are a collapse of memories of Palestine across time and space. Images of rolling hills with orange and olive orchards reflect both the memory of Gaza's now flattened lush citrus trees as well as the memory of the villages that refugees had left behind.

Importantly, when thinking about the future symbol of Gaza, and directions in local identity formation, intergenerational eco-imaginaries of the land play a key role. The landscape of Palestine visible to most of the

6. Graffiti, murals and street art across the occupied Gaza Strip showing the interlacing of the orange, the olive and trees with resistance, liberation, justice, and return in the public imaginary (Shourideh C. Molavi, 2019).

younger generation in Gaza is not one of sprawling orange or olive orchards like it had been for their parents and grandparents. Instead, produce like strawberries, watermelons, and, now increasingly, pineapple—all of which are embanked by a heightened urbanization in the strip—shape the landscapes of young Gazans. Similarly, these forced transitions in cultivation also produce new types of knowledge production, cultivation practices, and even cuisines among younger families and generations of Palestinians in Gaza, placing them further apart from the rest of Palestine. As Giulia Grechi illustrates, as the first step in food production, cultivation practices are key to the creation of colonial imaginaries. And once consumed, these products and their political meanings enter our bodies both literally and figuratively, constituting our very selves.

> Colonial imaginaries and representations are like an under-ground river, invisible but ubiquitous. They are within our mouths, our digestive systems, our ears and our voices. We have inhaled them in certain smells, and they have nourished us and imbued our white skin [...] We have, quite literally, incorporated them [...] The body is the main place of this memory, a memory which is translated and reproduces itself through us.[60]

Despite this, the images of Gaza, and by extension the Palestinian liberation movement, that cover today the streets are those of a Gaza that most young people in the region will not have experienced first-hand. And so, the type of symbols and identity anchors that will be adopted by this generation as part of their self-understanding, self-nourishment, and resistance, and the eco-imaginary that will form their individual consciousness of Gaza and Palestine, remains to be determined.

Chapter 3

The Al-Shawwa Citrus Export Company

In March 2018, I traveled to the occupied Gaza Strip once again to conduct workshops with upper-year high-school students at the Qatari-funded Al-Fakhoora Schools in Gaza City. The workshops were on visual and spatial methodologies for documenting long-term ecological changes in Gaza, but the trip to Gaza—a position of privilege given the extreme difficulties for entry and exit to the besieged strip—was also part of a research project with Forensic Architecture that I was leading into environmental violence in Gaza through regular seasonal herbicidal spraying by the Israeli occupation forces.

Gaza's streets were fluttering with renewed energy in these weeks. Organizers were preparing for the launch of the Great March of Return and the End of the Siege in Gaza, weekly marches along the eastern 'border' of the strip to commemorate seven decades of *Nakba* and call for the Palestinian Right of Return for refugees. During this trip, I worked closely with two young researchers at *Ain Media Gaza*—now two of my dearest friends in Palestine—Roshdi Al-Sarraj and Shurouq Alaila. Together with Shurouq and Roshdi, I traveled from farm to farm along the eastern perimeter, asking farmers about their cultivation history, the effect of herbicidal spraying on their crops, and their memory of the citrus industry in and around Gaza. The majority of farmers, many of them Bedouin, and also many women, recounted to us their memory of the landscape that existed, one that was dominated by trees—fig, pomegranate, olive, almond, and of course citrus. And almost all of them had since transitioned to lower-growing and faster-yielding crops to adhere to Israeli-enforced policies of cultivation along the 'border,' fearing the loss or bombing of their lands if they continued cultivating their trees. Today, their farms produce, eggplants, watermelons, zucchini, and a whole range of leafy vegetables and herbs including spinach, parsley, and chives, a sharp transition from the landscapes they had grown up witnessing. The scars on this landscape also translated to literal scars on their bodies. Most of the farmers we visited lived on the lands on which they worked with their families. As they would generously share stories of their cultivation history, and the transitions they made to cope with colonial policies of the occupation, climate change and neo-liberal shifts in local and international market demands for produce, they would also recount stories of their own injuries from working on their lands. I was repeatedly shown scars and marks on their bodies from shrapnel and bullets shot by Israeli

snipers from a distance, that hit Palestinian farmers as they worked on their lands. Despite having worked their way through the near-impossible Israeli permit system to continue to cultivate their lands along the border, including having access to their lands at certain hours of the day for harvest and upkeep, almost every farmer I spoke to had experienced being fired at by Israeli snipers while doing this work. Evidently, being a farmer in Gaza literally meant putting their bodies on the line. Farmers also shared the restrictions imposed on their living by the local *Hamas*-controlled government. Constant surveillance and monitoring also by *Hamas* and *Islamic Jihad* meant that movement by farmers on their lands was controlled. They felt constantly watched and frustrated. having to also follow the internal Gazan permit process for tending to their lands while receiving no support or protection from the local authorities.

In response to this abandonment, farmers have self-initiated practices of decolonization through campaigns to unionize agriculture. Working through the Gaza branch of the *Union of Agricultural Work Committees* (UAWC) which represents local agricultural committees in rural and urban areas as well as refugee camps, farmers along the eastern 'border' work to ensure access to land and natural resources to maintain their livelihoods. UAWC also supports farmers by facilitating access to agricultural tools and expertise for Gazan farmers living under occupation to develop new cultivation practices that respond to the demands and pressures of neo-liberal markets and climate change. Whether it is the introduction of new and previously foreign crops into Gaza, like pineapple and broccoli, or the building of novel infrastructure for cultivation, like the hanging strawberry farms of Beit Lahiya, UAWC works with farmers to produce more sustainable solutions in agriculture to counters the export blockade regular encroachment on their lands and water scarcity in the strip. As a direct challenge to Israeli eco-colonial practices, and despite having no affiliation with Palestinian political factions, UAWC was designated as a 'terrorist organization' by the Israeli Ministry of Defense in November 2021, alongside five other leading Palestinian human rights organizations.[61] Despite international condemnation of this outrageous designation, the work of UAWC has as a result become increasingly stigmatized also putting pressure on their ability to garner international funding.

During my visits to Gaza in 2018, I worked most closely with two farmers, Adham in East Jabaliya and Mona in Khan Younes. Adham was born into a family of farmers. Historically they planted orange and olive trees on their lands, which stood at a higher elevation and directly faced the encroaching border. He no longer lived on the land and would commute daily to tend to his crops. During the *Great March*, a protest camp was built directly facing his land, and he recounted the daily negotiations that took place between him and protesters to respect his property and crops during their activities

and processions. And when the occupation forces fired teargas using drones and shot live ammunition in the months of the *Great March*, they did not discriminate between protester and farmer. Part of my regular visits to Adham's farm therefore was receiving an update on the latest attacks he had endured from the Israeli army, as he showed me his stockpile of deployed teargas cannisters that landed in and around his farm. Having witnessed the violent transitions of the landscape in East Jabaliya, Adham was able to share details of how Israeli eco-colonial practices of bulldozing, razing the land, and now also herbicidal spraying compelled farmers around him to shift their cultivation techniques. The use of greenhouses, plastic tarps to cover their produce, and shifting to low-growing crops were all responses to both the encroaching buffer zone and the tools of colonial erasure Israel was adopting from a distance. When considering what to plant, Adham recounted that nightshades like parsley, for example, were out of the question, because harvesting in the evenings or at night when they would blossom meant increased risk of being shot by a sniper. At the same time, despite the elevated location of his farm vis-à-vis the border area, he insisted on growing trees, knowing full well and having already experienced bombing on his land due to the trees planted. I pressed him to understand the desire to continue with tree cultivation, and while admitting that in today's Gaza it was less cost-effective, took longer to yield produce, required more water and equipment, and was not responding to market demands, we eventually arrived at the core reason: "I prefer trees." This is the landscape Adham was used to seeing and what gives his work meaning both personally and politically despite the obvious risks and limitations. In these ways, the links between eco-political imaginaries and identity formation become clear.

In a similar vein, Mona, a Bedouin farmer in Khan Younes originally from Southern Palestine, also insisted on finding creative ways to preserve the Palestinian landscape she had grown accustomed to seeing as a child. Indeed, recent scholarship has documented the ways in which, in contrast to the simplistic representations of Bedouins as removed from the state and local and global markets of exchange, these communities were in fact a key part of agricultural industry in Southern Palestine, with cultivation practices as part and parcel of their self-understanding and identity.[62] Mona was one of dozens of women farmers I encountered along the Eastern perimeter, who both lived and worked on their farmlands. Over the past decade, Mona's family farm has had to transition into lower-growing crops, both to meet Israeli-imposed regulations regarding the types of crops that could be grown *en masse* along the 'border,' given also that Khan Younes is a flatter terrain directly liming up to the encampments of the IOF on the other side, and to ensure that the produce they were growing was profitable and responded to local demand. Peppers, herbs, eggplant, and even

broccoli—a first for Gaza and largely foreign to Palestinian cuisine—had come to dominate their crops. "First we had to learn how to grow broccoli," said Mona, "and then we had to teach people how to cook it, to incorporate it into our regular cuisine." She explained that many people would resort to feeding the broccoli to their livestock instead. Refusing to limit her output to low-growing fruits and vegetables, Mona would strategically place olive trees among her crops. She planted lone trees, sporadically across a field of parsley and, rather ingeniously, noted that this too served as an effective technique for cultivation. One takes the water from the top, and the other from under the soil, and in so doing, both the deep roots of the olive trees and the otherwise fragile leaves of the parsley would mutually reproduce. Similar to Adham, in our conversations Mona would recount that despite the risks of planting these trees so close to the 'border' and the limited size of the harvest that a handful of trees would produce, their presence on her lands served the broader personal and political aim of preserving a Palestinian landscape that she recognized.

Confronted by neo-liberal fluctuations in market demand, climate change, as well as a colonial eco-imaginary imposed on their lands and livelihoods by Israel, farmers like Adham and Mona are forced to make daily concessions and sometimes make painful decisions when it comes to determining what to cultivate. Knowing the risks involved with planting and maintaining trees along Gaza's hyper-militarized borders it was clear that in these often impossible calculations, their contribution to the Palestinian liberation struggle came in the form of creative and subversive cultivation practices such as these. Responding to the forced biopolitical modifications of their otherwise familiar landscape, such acts of resistance interrupt the colonial and imperial gaze, also emphasizing the inextricable role of the environment in modern warfare.

All that remains

In Gaza, the al-Shawwa family name is synonymous with the citrus industry. Born in 1909, Rashad al-Shawwa was a local activist who contributed to the economic sector in the Gaza Strip, later serving as mayor of Gaza for eleven years from 1971 to 1982. A key part of his efforts was to develop major investment in and support for the export of Gazan citrus to European and regional markets. Rashad's investment in the citrus industry also involved establishing a juice factory near Salah al-Din Street, the building for which still exists in northern Gaza. His son, Mansour al-Shawwa, also became a leading Palestinian businessman and entrepreneur in the 1980s and later served as the Head of the *Gaza Citrus Union*. Mansour worked to export

Palestinian produce, fruits and vegetables, to support farmers and laborers on the land in the face of an encroaching Israeli occupation. Institutions established by other members of the al-Shawwa family, whether agricultural, economic, infrastructural, or cultural also grew out of and contributed to the citrus industry in the Gaza district. In fact, even the Bank of Palestine, today the largest Arab-led bank in Palestine, was established in 1960 in Gaza by Hashem al-Shawwa in Gaza. Initially established as an agricultural bank, the Bank of Palestine helped farmers develop their citrus business with loans for farming equipment.

The last remaining site of Gaza's now-lost historic citrus production is the Al-Shawwa Beit Hanoun Gaza Citrus Export Company (also called the Al-Shawwa Citrus and Vegetables Packing House). Located in north-eastern Gaza in Beit Hanoun and opposite to the Israeli-imposed border, the Al-Shawwa Export Company was built during the British Mandate that remained open after the establishment of the State of Israel until the Oslo Accords. Today it continues to remain a massive compound, embanked by one of the largest remaining citrus and olive orchards in Gaza, serving as the last space in Gaza to host the memories of its citrus export industry.

Presently closed, this important site is testimony to the disappearing trees of Gaza and the deep-rooted social fabric that it once maintained through community-based labor relations, local consumption, and the mobilization of the agricultural space that surrounds it. Until now, this site has not been documented in any form, or in any scholarly or artistic publications.

Speaking to its present owner, Faisal al-Shawwa, we learned about the intricate social, familiar, economic, and communal relations that were formed over the decades through interaction with the company. As a source of labor, income, produce, and community in Beit Hanoun, the Al-Shawwa Export Company carried the livelihoods of the village, providing it, and by extension the Gaza district, with an identity centered around the citrus industry. With exports across the Middle East as well as Europe, the Al-Shawwa Export Company was a site where citrus was collected, washed, wrapped, packed, and loaded onto trucks using wooden crates. As we walked through the now-deserted factory space—a massively open area and an uncommon sight in the densely populated Gaza Strip—the infrastructural remnants of a lively citrus industry remained: old packing trucks, folded wooden crates piled to the side, as well as German-made and Hebrew inscribed machinery in an assembly-line set-up for washing and organizing citrus ahead of their export.

7. Still of drone footage of Al-Shawwa Beit Hanoun Gaza Citrus Export Company and image of its present owner, Mr. Faisal al-Shawwa during our interview on-site (Ain Media Gaza and Shourideh C. Molavi, 2019).

8. Still of drone footage of remaining historical orchards that today surround the Al-Shawwa Beit Hanoun Gaza Citrus Export Company (Ain Media Gaza and Shourideh C. Molavi, 2019).

9. Inside the Al-Shawwa Beit Hanoun Gaza Citrus Export Company. Wooden crates formerly used by workers to pack citrus for export. With the collapse of the citrus export industry in Gaza, the factory is today converted into a storage site for concrete blocks stored in the main area of the Al-Shawwa Company (Ain Media Gaza and Shourideh C. Molavi, 2019).

A testament to a once-flourishing industry, the site itself including its surrounding orchards had been repeatedly bombed in successive Israeli onslaughts in 2008–2009, 2012, and most recently at the time in 2014, explained Faisal, with the scars of the dropped missiles still present on the factory roof and part of the site reduced to rubble. (Indeed, most recently during the 2023 devastating Israeli onslaught, the Al-Shawwa factory was further evacuated and bombed.) Perhaps the most precious moment in our conversations with Faisal was visiting the old administrative office of the factory, also bombed in the 2014 war. Half-flooded and half-destroyed, the office was composed of two connected rooms full of paperwork related to the daily management and functioning of the Al-Shawwa Export Company. Looking through the remaining abandoned cupboards, we found receipts of quantities of citrus ordered, costs and rates of purchase per crate, wage slips, employee memos, work schedules, order forms and other documentation dating back to the 1960s and 1970s—some of which carried the original thumbprints of laborers in the company as their signature. Names of employees, messages of good-will for Ramadan from the employer, and order forms to export Gazan oranges to neighboring countries in the region. To our astonishment, we were looking at the last remaining archive of the citrus industry.

Used as a looking glass, the Al-Shawwa Export Company is a testament to the forms of Israeli neo-colonial violence that give shape to Gaza's present-day isolated reality, erasure, and environmental degradation. In the face of forced transitions in cultivation in the Gaza Strip and the concerted colonial erasure of the citrus industry along the border, the site is today used as a secured open-air storage site for blocks of concrete—another rare and valuable commodity in contemporary Gaza. The contrast between the life that traveled within the walls of this factory for decades and its present-day use was stark for all of us. Riddled with towers of concrete blocks lined up as a kind of maze, waiting to be used in the reconstruction of destroyed buildings in Gaza during Israeli attacks, the Al-Shawwa Export Company is a site of waiting, cut off from the neighborhood with a locked gate and facing inwards.

10. Images of receipts from the 1970 and 1980s of purchases of citrus from the Al-Shawwa Beit Hanoun Gaza Citrus Export Company and their shipment across the Middle East and North Africa. These receipts were among other historical documents, administrative notes, and reports collected first-hand by the author and local collaborators that remained inside the Al-Shawwa Company after its closure and repeated bombings by the Israeli occupation forces (Ain Media Gaza and Shourideh C. Molavi, 2019).

Al Shawwa Citrus & Vegltables
Packing House
Beit-Hanoon - Gaza
Tel Gaza 62750 Beit Hanon 15
P. O. Box 82

محطة الشوا للتعبئة وتصدير
الحمضيات والخضار

غزة ☎ ٦٢٧٥٠ ـ بيت حانون ☎ ١٥
ص . ب ٨٢

الشهر يونيو ٨٦
نوع العمل كبس
الأجر اليومي ٨,٥
أجر الساعه

بطاقة عامل

الرقم
الاسم جمعه الشعراوي
تاريخ ابتداء العمل

	يوم	ساعة		يوم	ساعة		يوم	ساعة		يوم	ساعة		يوم	ساعة
١	يوم		٩	يوم		١٧			٢٥	يوم				
٢	يوم		١٠	يوم		١٨			٢٦					
٣	يوم		١١	يوم		١٩	يوم		٢٧					
٤	يوم		١٢	يوم		٢٠			٢٨					
٥	يوم		١٣			٢١			٢٩	يوم				
٦			١٤	يوم		٢٢	يوم		٣٠	يوم				
٧			١٥	يوم		٢٣	يوم		٣١		يوم			
٨			١٦			٢٤			مجموع					

مجموع الايام ١٨ × = ١٥٠٩
مجموع الساعات ١ × = ١,-
اجمالي الاجر ١٥١٩

توقيع العامل
توقيع الصراف
التاريخ ١٩٨٦ يونيو

Chapter 4

Israeli herbicidal warfare as colonial practice

We begin with the recognition that the Earth is wretched. This is not a metaphor. It is literally our ground. The Earth is wretched because its soil—that thin layer at the surface of the planet upon which we depend for life—is contaminated, eroded, drained, burnt, exploded, flooded and impoverished on a worldwide scale.

—Ros Gray and Shela Sheikh

As social and architectural constructs (re)produced through daily practices, environmental landscapes are a medium through which relations of power are solidified. Here environmental law enforcement and warfare—practices that compel the conditions of the terrain or agriculture to collude with the conditions of security and surveillance—are mobilized by colonial and imperial states to reconfigure biopolitical landscapes according to violent political logics and projects of exclusion. For example, from 2009 to 2011, US military operations in the Arghandab River Valley in Afghanistan razed and flattened "mudbrick walls, homes, and dense foliage" to establish lines of sight against insurgent cover so as to support durable lines of force.[63] As part of their counterinsurgency practices, the military trained Arghandab farmers in "pruning practices for the overgrown pomegranate trees that hindered military patrol mobility," and pushed forward the planting of alternative crops with 'straight' and 'rational' layouts to enable more effective military patrolling in the area.[64] Similar environmental practices are used by sovereign powers to organize and regulate the movement of criminalized bodies and racialized communities as part of their internal border-control measures. For instance, in the case of the migrant camp, known as the Calais 'Jungle,' forced socio-spatial transformations of the landscape weaponized the terrain on which the camp sat.[65] With changes to the discourse on migration, from a "moralistic humanitarian imperative to help refugees," to the portrayal of "migration as a threat against an imagined ethno-nationalist base," the camp was demolished by the French government with the argument that its terrain be 're-naturalized' and re-integrated with the surrounding natural environment.[66] Here, the landscape itself was mobilized and militarized by the state as an instrument of power to legitimize displacement and reproduce racial hierarchies.

Complementing practices of environmental law enforcement and warfare, the use of herbicides in aerial fumigation first entered the repertoire of counterinsurgency tactics of imperial powers after World War II. The deployment of Agent Orange over Vietnam by the US Air Force is possibly the most known example where, from 1961 to 1971, the US military dropped around 19 million gallons of defoliants over large areas of South Vietnam.[67] Aimed at operationalizing a sovereign cartographic gaze, the use of Agent Orange as an experimental form of chemical and biological warfare stripped foliage to improve visibility and to deprive communities of food supplies. Responding to these forced biopolitical modifications of the landscape, broad-based resistance movements in rural areas interrupted the colonial and imperial gaze by compelling these powers to recognize the inextricable role of the environment in modern warfare.

In 1971, the agrochemical corporation Monsanto invented glyphosate, a broad-spectrum herbicide meant to dissipate in the soil. Used in places like Colombia in the context of a decades-long War on Drugs, glyphosate was aerially sprayed with the declared aim to eradicate plants that fueled the drug trade. Indeed, as recently as April 2019, herbicide spraying was approved as a practice of border control by the Texas Senate, to battle 'illegal' immigration from Mexico.[68] Seeking to align the lines of sight with the lines of force, herbicide spraying campaigns by colonial and imperial powers aimed at modifying environmental and political landscapes therefore surfaces as a tool for modern law enforcement and warfare.

Herbicidal warfare in Gaza

Since 2014, the settler-colonial modification of Gaza's environment through the clearing and bulldozing of agricultural and residential land along its eastern perimeter has been complemented by the unannounced aerial spraying of crop-killing herbicides. This practice targets not only the health and livelihoods of Palestinian farmers along the border, but also the landscape itself, leaving its traces deep within the soil of Gaza as the infrastructure of life.[69]

11. Still images of video of Israeli crop-duster plane flying along the occupied eastern perimeter of the Gaza Strip while spraying crop-killing herbicides (Ain Media Gaza and Shourideh C. Molavi, 2019).

The IOF first began spraying herbicides by air to raze Palestinian fields in Gaza along its imposed buffer zone from 11–13 October 2014.[70] This practice has since been continuously applied in key harvest periods resulting in the destruction of entire swaths of formerly arable land and the loss of livelihoods for Gazan farmers. The spring and winter of 2019 were the first two seasons during which the military has not conducted aerial spraying in the past four years. However, the Israeli Ministry of Defence (MOD) has yet to officially declare ceasing this devastating practice altogether. As part of the continuum of Israeli settler-colonial practices, aimed at the territorial, demographic, and political control of Israeli-Jews over indigenous Arab-Palestinians, herbicide spraying serves as an additional modification tool of the lived and natural environment in Gaza.

In December 2015, the Israeli army first confirmed that it used crop dusters for the herbicidal clearing of vegetation and crops along the border with Gaza. The army spokesperson stated that "[t]he aerial spraying of herbicides and germination inhibitors was conducted in the area along the border fence [...] in order to enable optimal and continuous security operations."[71] The objective is to eliminate tall plants growing close to the border in order to enhance visibility for Israeli military operations. In effect, Israel has declared aerial herbicidal spraying on the border in Gaza to be an 'act of warfare'—one that operationalizes a settler-colonial cartographic gaze.

In November 2016, in response to a Freedom of Information (FOI) request filed by *Gisha*, the MOD clarified that "the Ministry is not carrying out any aerial spraying over the area of the Gaza Strip," and that "the aerial spraying is conducted *only* over the territory of the State of Israel along the security barrier with Gaza."[72]

It confirmed that the spraying operations are conducted only along the width of the perimeter with Gaza, between the Erez Crossing in the north and Kerem Shalom in the south, the length of which is 58 kilometers with an estimated area to be sprayed at 12,000 dunams.[73] Citing provisions of the *Israeli Plant Protection Law*, 5716-1956, the MOD claimed that its spraying on the border is "identical to the aerial spraying carried out throughout the State of Israel."[74] The Gaza Division of the MOD decides on the sprayings and applies for permits from the Jewish National Fund, the Green Patrol,[75] and the Authority of Nature and Parks. As the Israeli Ministry of Agriculture (MOA) is not involved in the spraying operations, the MOD conducts herbicidal spraying with the instructions of a contracted civilian agronomist.

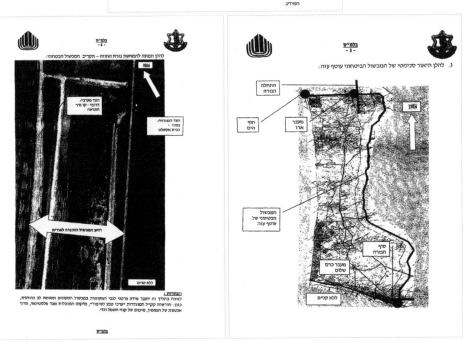

12. The Israeli government's response on 29 November 2016 to a Freedom of Information request filed by the *Gisha Legal Center for Freedom of Movement (Gisha)*.

Following the instructions of the agronomist, Israeli military spraying is conducted in the two key winter and spring harvest seasons, targeting winter and summer crops. Spraying is conducted in the mornings from 06:00, however, the actual time and day of the spraying of herbicides by the IOF is not announced beforehand.[76] Contracting two private Israeli civilian aviation firms—Telem Aviation from 2014 to 2016 and Chim-Nir from 2017 to the present—to carry out the extermination of vegetation, the destruction of vegetation along the eastern perimeter is carried out in a continuous manner using two aircraft simultaneously, each equipped with a GPS system to ensure precision. In February 2019, responding to another FOI submitted by *Gisha*, it was revealed that between 2014 and 2018 the MOD has sprayed herbicides by air at least 30 times.[77] However, upon compiling the documented testimonies of Palestinian farmers, legal researchers, and civil society fieldworkers in Gaza, the author counts approximately 42 separate instances of aerial herbicidal spraying since 2014, most with reported damage by farmers, by either the IOF or by Israeli farmers along the border area.

The army's response to the November 2016 FOI confirmed that it sprays a combination of three herbicides: glyphosate, oxyfluorfen (Oxygal), and diuron (Diurex). Glyphosate, formulated as Roundup—a flagship of the Monsanto Company—is the world's most widely used herbicide, leaving traces in soil, foodstuffs, air, and water, as well as human urine. In March 2015, one year after Israel began spraying Roundup along the border with Gaza, the *World Health Organization's* Cancer Research Agency classified glyphosate as "probably carcinogenic to humans."[78] Since then, the US Environmental Protection Agency, The European Food Safety Authority, and the European Chemicals Agency have ruled it safe for use, although a number of European environmental authorities have been critical of this ruling.

Manufactured by the Israeli company Tapazol Chemical Works Ltd, oxyfluorfen, formulated as Oxygal, is an herbicide suppressing the growth of certain broad leaf and grassy weeds. This herbicide is moderately persistent in most soil environments with a representative field half-life of 30 to 40 days. As per the Material Safety Data Sheet guide provided by its Israeli manufacturer, Oxygal can cause severe irritation if in contact with skin or eyes and must be kept out of water supplies and sewers.[79]

Weaponizing the wind

Testimony of Palestinian farmers collected by the author, as well as reports by *Al-Mezan*, confirm that prior to spraying, the Israeli army uses the smoke from a burning tire to determine whether the wind direction goes into Gaza.[80]

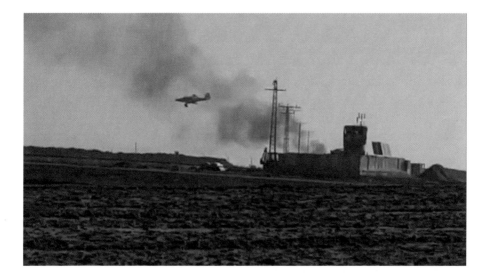

13. Still image of video of Israeli crop-duster plane flying along the occupied eastern perimeter of the Gaza Strip with smoke from a burning tire in the background to determine wind direction (Ain Media Gaza and Shourideh C. Molavi, 2019).

In their response to the November 2016 FOI, the MOD writes that "ground workers for the contractor will place flags, *inflammable tires* or any other means for carrying out the extermination" and that "these ground workers will have continuous communication with the officials in charge of the aircraft."[81] Although not confirmed by the MOD, it can be reasonably assumed that the purpose of inflammable tires along the border as part of the army's spraying protocol is to determine wind direction. Indeed, wind direction is a key factor that determines the movement of aerial herbicides

from the purportedly targeted area. When effective drift control techniques are not applied, the Israeli army cannot mitigate the reach of those chemicals into Gazan farmlands.

Plant scientists have noted that under similar environmental conditions, and with all sprayers adjusted properly, herbicide drift is "generally greater from aerial application than from ground application," and that the use of ground-based field crop sprayers through tractors reduces the likelihood of extensive drift.[82] In an investigation I led with the team at Forensic Architecture, with close consultation and research supervision by Eyal Weizman, we were able to show that once sprayed, the herbicidal toxins sprayed by the IOF along the border are carried by the wind deep into Gaza—with wind speed and direction relative to the flight path as key environmental factors in determining the final impact of herbicidal spraying. But here too, environmental factors coincide with an apartheid structure for protection recognition and compensation that underpins the State of Israel. The colonial erasure of Palestinian existence through herbicidal warfare became further apparent after a confirmed the spraying by the Israeli army in 2015, Israeli residents of Kibbutz Nahal Oz living immediately on the other side of the Gazan border experienced unexpected agricultural loss and damage. On 16 November 2015, spraying for sterilization of agricultural land was carried out by the Northern Battalion of the Gaza Division of the army for operational purposes. Wheat crops sown in October 2015 in that area were scorched and dried up with no ability for growth on a land spanning 50 dunams. The toxicity of this spraying also prevented the Kibbutz from planning watermelons for the following season.[83] Demanding compensation "following unsupervised spraying activity on active agricultural lands," the MOD paid the Kibbutz 61,900 NIS under a compromise agreement.[84]

The case of Kibbutz Nahal Oz reaffirms that spraying herbicides by air is an inaccurate and less readily controllable method of application.[85] The damages also confirm that low-growing crops are more vulnerable to this poison in various harvest periods as the toxins remain in the soil across seasons. However, while Israeli-Jewish farmers qualify for compensation, Palestinian farmers a few hundred meters on the other side of the border perimeter fall under the legal framework of Israeli military law and are denied the same protections and accountability. In June 2016, a claim on behalf of eight farmers in Gaza was filed by *Al-Mezan*, *Gisha*, and *Adalah*, seeking compensation for damages caused by aerial crop-spraying by the Israeli army in al-Zanna and Abasan al-Jadeda, in the border area east of Khan Younes.[86] The complaints amounted to a total affected land area of 81.3 dunams, with an immediate loss for farmers estimated at $14,550, plus approximately $18,500 in water costs required for irrigation and replanting of the destroyed fields.[87] In one of the complaints put forth, the herbicides reached a four-dunam agricultural

plot farmed by Abu Ta'aymeh approximately 700 meters from the buffer zone inside Gaza, reportedly destroying the harvest and causing significant harm to the land itself. The petition held that the Israeli military's aerial spraying of herbicides constitutes a violation of both Israeli constitutional and administrative law, as well as of international humanitarian and human rights laws.[88] According to the *Fourth Geneva Convention (1949)* and *Additional Protocols (1977)*, parties to a conflict must protect civilians and humanitarian interests during wartime and occupation, must refrain from causing harm or damage to civilian targets such as agricultural lands, and must respect the right of protected civilians to access food.[89] The Israeli military's spraying of herbicides on agricultural crops which serve as a basic food source, while also taking into account the ongoing closure of Gaza, constitutes a violation of Article 55 of the *Fourth Geneva Convention*.

Yet, on 2 November 2017, the Insurance and Compensation Section of the Israeli MOD notified the human rights organizations of its decision not to provide compensation or reparations to Gazan farmers.[90] Although recognizing its involvement in the spraying, the MOD does not hold itself accountable to the civilian population in Gaza, nor is it willing to provide reparations in accordance with its international obligations. Moreover, *Gisha* reports that the MOD has "failed to explain why the spraying was carried out, and why the same result could not be achieved using less destructive methods."[91] To date, no Palestinian farmers have ever been compensated for damages to their crops resulting from herbicide spraying.

Environmental Law Enforcement: Saleem Abu Medeghem v. Israel Lands Administration

The Gaza Strip is not the first area where Israel has employed aerial herbicidal spraying against Arab communities causing extreme risk to human health and disproportionate agricultural damage. In February 2002, the Israel Lands Administration (ILA) launched a crop-spraying policy in the *Naqab* over lands cultivated by Arab Bedouin citizens of Israel who live in villages in the *Naqab* categorized by the State as 'unrecognized villages.'[92] An extension of Israel's ongoing settler-colonial practices, this policy sought to modify the biopolitical landscape of the *Naqab* through modernization project aimed at forcibly transferring the indigenous population to engineered cities with a reconfigured and reorganized material space. The policy enforces the right of the State over the territory by pushing the Arab Bedouins off of their lands on the grounds that the community is 'trespassing' on 'state land' to 'illegally' cultivate the fields.[93]

This biopolitical modification began in the form of demarcating the areas targeted, placing ground forces to prevent local residents from getting near, and destroying crops with the use of tractors. However, between 2002 and 2004, this practice was replaced with the use of aerial crop-dusting planes that spray toxic substances designed to destroy weeds. Carried out by Chim-Nir, a private aviation company based in Herzliya, Israel—and the same company that was later also contracted to spray along the border with Gaza—a combination of three different types of chemicals were applied: Roundup, Typhoon, and Glyphogen—all of which are procured from glyphosate. Over 28,000 dunams of low-growing crops including wheat, barley, and vegetables were sprayed in twelve Arab Bedouin villages, including with chemical herbicides that were not authorized by the MOA at the time of spraying.

On 22 March 2004, the *Adalah Legal Center* submitted a petition to the Supreme Court of Israel that challenges the ILA's operations of spraying crops with toxic chemicals, on behalf of four Arab Bedouin citizens living in unrecognized villages, *Physicians for Human Rights-Israel*, the *Forum for Co-Existence in the Negev*, the *Arab Association for Human Rights*, *Bustan for Peace*, the *Galilee Society*, the *Negev Company for Land and Man Ltd.*, and the *Association for Support and Defense of Bedouin Rights in Israel*. In that year, the Israeli government implemented a $225 million plan (approximately 1 billion NIS) to relocate Arab Bedouin citizens living in 'unrecognized villages' to seven newly established towns. Two-thirds of the budget for this plan was reserved for 'environmental law enforcement in the Negev,' and included resources for herbicide spraying and home demolitions.[94] Once the petition was submitted by *Adalah*, the Court immediately issued an injunction prohibiting the ILA from continuing this practice, and later extended this position until a final decision was to be reached.

On 15 April 2007, the Supreme Court delivered a precedent-setting decision prohibiting the aerial spraying of crop-killing herbicides by the ILA on lands cultivated by Arab Bedouin citizens living in the unrecognized villages in the *Naqab*. The decision also ordered the State to pay 20,000 NIS in legal fees. The following determinations in the Supreme Court ruling on *Abu Medeghem v. ILA* are relevant to the findings of the investigation conducted with *Forensic Architecture* into aerial herbicidal spraying along the border with Gaza:

Topic	Israeli court findings on herbicide spraying in *Naqab*, 2002–2004	Applicability to herbicide spraying along the Gaza Strip, 2014–present
Risks associated with the Round-up herbicide	As part of the case, a 2004 expert opinion regarding the use of Roundup written by Dr. Eliahu Richter of the Hebrew University stated:	Since 2014, the same chemical, Roundup, has been sprayed at the beginning of key harvest seasons along the border in Gaza by the army.
Risk of exposure and damage due to aerial drift	"The spraying of Roundup in the vicinity of inhabited communities clearly defies the warning label; Roundup spraying carries a potential risk of exposure as a result of spray drift; the agent is a suspected carcinogen and has a disruptive endocrinal (hormonal) effect; [and] aerial spraying of Roundup is a public health hazard."[95]	The findings of the investigation also highlight the damaging effects of risk. It reveals that the concentration of herbicides that landed over 350 meters from the border after the 5 April 2017 spraying event in Khan Younes were above the recommended amount for drift according to EU recommendations.

Further, the investigation shows that the Israeli army protocol of spraying herbicides by air *while wind travels into Gaza* has uncontrollable effects. |
| *Aerial spraying of Roundup as a public health hazard* | | The risk of a public health hazard is also a factor as each spray leaves behind a unique destructive signature rendering the damage on the land per spray largely unpredictable. |

Endangering human life and health	The panel of three Justices of the Supreme Court—Edna Arbel, Salim Joubran, and Miriam Naor—unanimously ruled that aerial herbicide spraying is prohibited because the chemicals endanger the human life and health of the inhabitants of the unrecognized villages, and because its practice "humiliates" and "disrespects" Arab-Bedouin citizens.[96]	While the civilian population in Gaza does not fall within the state-citizen legal framework of responsibilities that applies to Arab Bedouins in the *Naqab*, Israel bears the responsibility of an occupying power for the safety and welfare of civilians living in the Gaza Strip.
Violating human dignity	The decision also held that the practice of aerial herbicide spraying "harms the dignity" of the community, producing feelings of "contempt" and sending a "message of insensitivity" to Arab-Bedouin citizens on the part of the State.	
Lack of information or prior warning provided	During the spraying operations in the *Naqab*, "the 'Green Patrol' remained at a distance of 120 meters from the area."[97] A key issue for the Justices in their ruling was that the state itself admitted that in some cases implementation of the spraying operations was conducted without the giving of prior warning of, or information about the spraying operations.[98]	The protocols of clearing the area adopted during the spraying operations in the *Naqab* imply that the Israeli army is aware of the potential damage to human health caused by the chemicals sprayed. Despite Israel's aforementioned responsibility as an occupying power for the safety and welfare of Palestinians in Gaza, no warning or information is provided by the MOD to civilian and farming communities living and working along the border prior to aerial spraying.

Damage to private property	The Justices held that the state cannot justify its spraying of Roundup with the argument that farmers in other parts of the country use the same chemicals on their own lands. The Court ruled that despite precautions taken by the State, the spraying was "not done in cooperation with the owners and with the users on the land—even if it is illegal."[99]	As the investigation reveals, although the herbicide spraying itself is conducted along the border on the Israeli side, the parameters of the practice render damage to privately owned agricultural lands primarily on the Gazan side of the border.
Disproportionate effects of aerial spraying	The practice of aerial spraying as a form of 'environmental law enforcement' was considered by the Justices to be a "disproportionate measure" in relation to the declared objectives of the state.[100]	As an act of warfare, aerial spraying while wind goes into Gaza has the effect of damaging agricultural lands hundreds of meters away at higher than recommended concentrations. This renders the practice of aerial herbicide spraying disproportionate to the declared Israeli military objective of improving visibility for 'optimal security operations.'

Anatomy of a spray: Khan Younes, 5 April 2017

On 5 April 2017, a fieldworker with the NGO *Gisha Legal Center for Freedom of Movement* recorded two videos from the Gazan side of the border area near Khan Younes. The videos capture a Model S2R-T34 Turbo Thrush Aircraft that sprays herbicides along the eastern border of Gaza. The videos were provided to the author with the date and location of the spraying event confirmed by the Gisha fieldworker. The footage reveals that, before each spray, the plane dives to roughly 20 meters altitude to get closer to the ground. It covers the area that is set to be fumigated by taking linear paths and going back and forth. Over the course of the footage captured in the two videos, six spraying paths are covered, with each spray continuing for a duration of two to five seconds. All of the sprayings were conducted close to the border with Gaza, and on the Israeli side of the perimeter.

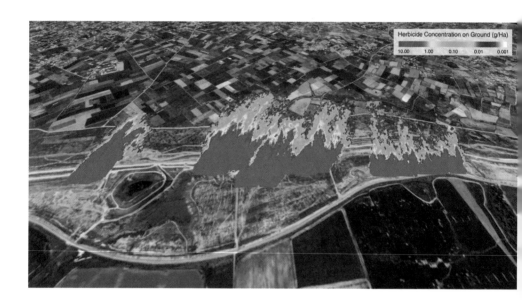

14. The results of Forensic Architecture's analysis show the distribution of concentration of herbicide as it travels westward into occupied Gaza (Forensic Architecture and Dr Salvador Navarro-Martinez).

Palestinian farmers in the area reported concern that their crops would be damaged as a result of the IOF spraying once carried by the wind, considering that crops were also harmed in the last round of spraying that took place only months prior. Further, most of the crops in the area had been recently sown

by farmers therefore making them particularly susceptible to damage from herbicide spraying. Using the videos collected by the *Gisha* fieldworker, I worked with a team at Forensic Architecture to investigate the effects of this aerial herbicide spraying event on neighboring Gazan farmlands. To determine the unique destructive signature of this spraying event, we began by threading together the material evidence, information derived from vegetation on the ground, the testimony of civilians living and working in the area, and the nature of the environmental elements mobilized in the event.

To begin, using the GPS location of the fieldworker as recorded on a smartphone, the camera cone of vision was established by comparing the dimensions of visible landmarks, such as a watchtower.[101] Through camera calibration the location of the plane was found and, using motion tracking, the path of the plane was modeled in the moments when it sprays herbicide, in both time and in space.

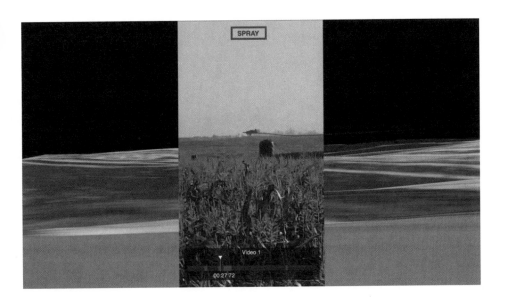

15. The flight paths seen in videos of Israeli aerial spraying provided to Forensic Architecture were mapped onto a 3D model (Forensic Architecture).

Using fluid dynamics, we then sought to determine the extent and concentration of the herbicide drift.[102] To this end, each spray event was simulated using the flight path reconstruction and the meteorological conditions at the time of spraying. Key variables such as wind direction,

wind speed, humidity, temperature, and the characteristics of the spraying system fixed to the plane were collected to determine the extent of drift. What became observable with the simulation is that, as wind moves across the path of the herbicide spray, it carries chemicals westward that are then deposited onto Gazan farmlands. Importantly, the simulation indicates that for the spraying on 5 April, and according to European standards on the use of glyphosate,[103] harmful concentrations of herbicide drift for most plants reached in excess of 300 meters into Gaza. This confirms that Palestinian crops likely would have been harmed as a result of herbicide drift.

From there, we conducted satellite imagery analysis to reveal visual indicators for the presence and health of vegetation in the area of Khan Younes, in and around the Israeli army's spraying on 5 April.[104] Satellite imagery from five days after the spraying on 11 April, and then 15 days after the spraying on 21 April was collected to reveal visual indicators for the presence and health of vegetation. Using remote-sensing—a technique of detecting and monitoring the physical loss of green vegetation in an area over time, also called the Normalized Difference Vegetation Index (NDVI)—durable traces of environmental violence in the form of vegetation degradation became visible across much of the same area potentially affected by herbicide drift.

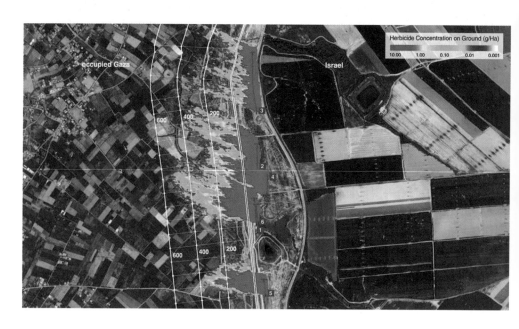

16. Still image of drift analysis overlaid on NDVI. The results of Forensic Architecture's analysis show the distribution of concentration of herbicide as it travels westward into Gaza (Forensic Architecture and Dr Salvador Navarro-Martinez).

Once combined with the results of the numerical models of herbicide drift across the eastern perimeter, the observed loss of vegetation appears to be due to fumigants carried by winds from the border into Gaza on the day of spraying. When overlaid, satellite imagery analysis corroborates the findings of the drift simulation, revealing that vegetation degradation becomes visible across much of the same area potentially affected by herbicide drift.

Following another confirmed spraying flight by the IOF on 7, 9, and 10 January 2018, the Gaza MOA actively surveyed over a hundred farms along the eastern perimeter that reported crop damage across the entire Gaza Strip, including: Northern Gaza (Beit Hanoun), the Gaza Middle Area (Jabaliya and Gaza City), Khan Younes, and Rafah. The original data surveys, collected around one week after the spraying event, were provided to us by Dr. Nizar Al-Wahidi, General Director of Orientation and Rural Development of the MOA. These important surveys collected the names of farmers, their identity number, date of spraying, approximate time of day, type of crop grown, and the dunams of damaged crops. However, the surveys did not include the exact location of the farm nor the distance of the farm with alleged damage to the border with Israel. To determine the location of the reported herbicide damage, and the distance of the alleged travel of the chemicals after this spraying incident, I contacted each of the farmers listed on the survey. And in July 2018, I was able to visit close to 50 sites along the border perimeter whose farmlands were documented as experiencing significant damage after the January 2018 IOF spraying.[105] This important fieldwork enabled us to locate almost half of the farms surveyed by the Ministry after the January spraying in relation to the border area. The interviews further revealed that, in the Khan Younes area, Palestinian farmers living hundreds of meters away from the border reported herbicide injury to their leafy crops totaling over 1,000 dunams following this spraying event. Once overlaid with the satellite imagery analysis—where the location of the affected farms in the Khan Younes area reporting herbicide injury after the January 2018 spraying are plotted in relation to the border—we found that the same areas in Khan Younes reporting vegetation degradation in 2018 after Israeli herbicide spraying also correspond with areas displaying vegetation loss in April 2017.

One year later in December 2018, we gathered similar samples of leaves three days after another IOF spraying that had exhibited characteristic damage from a contact herbicide. In the morning of 3 December 2018, farmers in the areas of East Gaza and Juhor ad Dik reported to Mr. Wael Thabet of the Department of Plant Protection and Inspection Services in the Gaza MOA that herbicide spraying was conducted by the Israeli army. This was confirmed as a spraying date by the Israeli MOD.[106] Three days after the spraying, I traveled to farms in these two areas in collaboration with the MOA to collect samples of leaves three days after an army spraying

that exhibited characteristic damage from a contact herbicide. With my colleagues we gathered leaves from four sites in East Gaza, and three sites in the Juhor ad Dik farming areas, with samples collected and composed of leaves from various types of plants at that site.[107]

17. Images of damaged leaves and vegetation on Palestinian farms along the eastern perimeter of Gaza after an Israeli herbicide spraying event collected by the author (Ain Media Gaza and Shourideh C. Molavi, 2018).

Zucchini (كوسة)
Sprayed 3 December 2018
Collected 3 days after spraying in Juhor
ad-Dik, 31.28.03'N; 34.26.3'E
Fungal, insect and possibly herbicide damage

'Sadaf' or Peas (بزيلا)
Sprayed 3 December 2018
Collected 3 days after spraying in East Gaza
31.33.7'N; 34.30.16'E
Possible herbicide damage

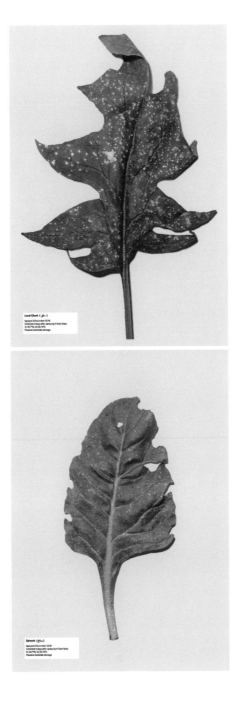

18. Images of damaged leaves and vegetation on Palestinian farms along the eastern perimeter of Gaza after an Israeli herbicide spraying event collected by the author (Ain Media Gaza and Forensic Architecture, 2018).

Each of the farming sites we visited were located at intervals of 200 meters from one another, starting from the eastern border, at approximately 700–800 meters away. In total, our leaves were from farms located 200, 400, 600, and 800 meters away, and at each interval we noticed different effects of the herbicidal drift on the vegetation, depending also on what was being grown. At each site, we spoke with Palestinian farmers who shared with us their practices of cultivation in response to ongoing and unannounced Israeli sprayings, and we asked them to recall the date of spraying, the approximate time of spraying, the type of crop grown, and the number of days after spraying when damage was visually detected.

Once collected, the leaves from each site were photographed individually, and then placed together and were weighed as a single collection from that site.[108] When looking at photographic images of leaves collected from each site, local weed specialists explained that damage from fungal pathogens, insect feeding, and possible herbicide drift was visible. The leaf samples were sealed in plastic bags and placed in a freezer at the MOA offices in Gaza City until a permit was issued by the Coordinator of Government Activities in the Territories of the Israeli MOD, with coordination from the Gaza Office of the International Committee of the Red Cross. On 10 December 2018—and after much diplomatic and political wrangling, with multiple permits and visas provided—the leaf samples made their coordinated way out of besieged Gaza through the Erez Crossing and arrived at the Katif Center Laboratories in Netivot on 11 December where they were tested for herbicides using liquid chromatography-mass spectrometry. Two days later the results arrived to our colleagues in Gaza showing that traces of insecticide and pesticides were found on the leaves but that damaging levels of herbicides were not detected. In essence, the results showed that the geographic and weather conditions on 3 December after this spraying event in the two areas of spraying did not result in traceable damage due to drift.

Taken together, thinking about the spraying event on 5 April 2017 in Khan Younes in relation to the findings of other spraying conducted by the IOF, our satellite analysis of vegetation health, farmer testimonies, and drift analysis all corresponded and lined up. They revealed that agricultural lands at over 350 meters away from that border experienced damage as a result of the herbicides sprayed by the Israeli army. Further, the concentration of herbicides that landed over 350 meters from the border in Khan Younes were above the recommended amount for drift according to EU recommendations. Working from the findings of these spraying events, three key conclusions regarding the colonial practice of aerial herbicide spraying along the border with Gaza may be extracted. First, regarding the practice of herbicide spraying itself, the investigation confirms that the main damage caused by Israeli aerial spraying is inside the Gaza Strip. This means that the steps taken by the

Israeli army to mitigate the damage are insufficient. Although the spraying itself is conducted along the border on the Israeli side, the parameters of the practice render damage to agricultural lands primarily on the Gazan side of the border.

Second, the investigation also reveals that the Israeli army protocol of spraying herbicides by air *while wind travels into Gaza* has uncontrollable effects, damaging Palestinian farms hundreds of meters away from the border. Significantly, this shows the function of the wind in Israel's settler-colonial occupation, in that its spraying of herbicides is conducted in a manner that mobilizes all environmental flows of energy available to maximize damage to Palestinian farmlands. The role of the wind is hugely significant, not merely because it links the colonial practice of herbicidal spraying to the real damage reported by Gazan agricultural workers along the eastern perimeter, but also because it reinforces Israeli culpability in the destruction of Palestinian crops from a distance. While the Israeli occupation authorities hold that they neither spray over Gazan lands nor enter the strip physically to spread crop-killing herbicides, the use of environmental elements like the wind to ensure the transfer of the toxins on Palestinian farmlands shows how the IOF mobilizes the sovereignty of the border, the buffer zone, to implement human, infrastructural and agricultural destruction.

Indeed, each spray leaves behind a unique destructive signature, with durable traces of violence after the spraying operation is complete. No two aerial sprays will have the same effect, nor can their damage be reasonably predicted by the IOF. For example, whereas the sprayings on 5 April 2017 and 7, 9, and 10 January 2018 caused damage to Palestinian farms hundreds of meters of away inside Gaza, the spraying on 3 December 2018 did not indicate damaging levels of herbicide drift in the leaf samples tested. This is because the location where the toxic chemicals land, and their respective concentrations, depend heavily on the direction and speed of the wind relative to the flight path of the aircraft.

Building on this point, the investigation also showed that the damage of the spray effects of aerial spraying is uncontrollable, and the damage on the land per spray is largely unpredictable. As such, this practice weaponizes herbicide spraying as a belligerent act of colonial violence aimed at damaging and erasing Palestinian access to and cultivation of the land along the Israeli-imposed perimeter. The IOF cannot reasonably determine the level of damage caused by aerial herbicides so long as the spray is conducted while the wind travels into Gaza, rendering it also disproportionate to the declared military objective of improving visibility for 'optimal security operations.'

The first of its kind, and on the largely understudied topic of environmental violence in Gaza, the findings of this initiative were

mobilized by *Al-Mezan*, *Gisha*, and *Adalah* to empower their petition against the Israeli practice of aerial herbicide spraying along the Gaza border. As part of their collective statement released on 21 July 2019 in coordination with the launch of this investigation, the three organizations stated:

> The aerial spraying infringes on fundamental human rights and violates Israeli and international law. There is no justification or legal basis for the continued use of this highly destructive practice, which causes disproportionate damage to residents of the Strip and their crops. We call on Israel to cease all spraying in the Gaza Strip area in the future.[109]

Although the Israeli MOD has yet to end this practice, the spring and winter of 2019 were the first two seasons during which the military has not conducted aerial spraying since the practice first began as an act of warfare. In response, the three organizations also released a video documenting the testimonies of farmers and herders whose livelihoods depend on the lands closest to the border area, attesting to the extreme benefits and potential of a season without spraying. Using the findings of this investigation—which revealed the uncontrollable effects of aerial herbicidal spraying and damage mainly to Palestinian farmlands—*Al-Mezan*, *Gisha*, and *Adalah* demanded the official ceasing of herbicide spraying.

Moreover, in a September 2019 report by the Special Committee to Investigate Israeli Practices Affecting the Human Rights of the Palestinian People and Other Arabs of the Occupied Territories—a committee within the Office of the High Commissioner of Human Rights—to the 74th session of the United Nations General Assembly also cites the findings of this investigation. The committee noted its "serious concern" about the practice, and in pointing to the destructive result on Palestinian farmlands from each spraying event it argued that "such herbicides should not be used in close proximity to the [Gaza border] fence."[110]

The collaboration built with *Al-Mezan*, the Gaza Ministry of Agriculture, and various farmers living along the eastern perimeter continued to develop after the launch of the investigation findings. During my meetings with farmers and fieldworkers we developed initial protocols for documenting potential future sprayings by the Israeli army. As the spraying is unannounced, with no prior warning given to farmers working and living near the border, farmers are unable to prepare their lands for the eventual drift of herbicides on their lands. Responding to this colonial belligerence, we created a network of farmers, enabling information transfer among communities in various parts of the Gaza Strip. Knowing that the army begins spraying from the north of the strip, working their way south, farmers would send encrypted group messages warning other farmers living further south of spraying

events underway, and enabling them to cover their crops before the planes reach their areas. This process includes instructions to fieldworkers on filming and locating potential spraying events, as well as procedures on the collection, documentation and testing of leaf samples along the border and facilitating their transfer out of Gaza to specialized laboratories.

Durable traces of colonial violence

Scars of the forced settler-colonial modification of Gaza's peripheries through unannounced herbicidal spraying, the latest practice to accompany regular clearing and bulldozing of agricultural and residential lands, remain visible today. As bio-indicators of an engineered colonial landscape, changes in crop cultivation and farming practices occur regularly along the border to enable farmers to maintain their livelihoods with the expanding buffer zone and changing rules of agricultural development imposed by the Israeli occupation authorities. To understand the long-term changes to vegetative health in Gaza in the face of these forced transitions in cultivation, and to determine traces of environmental damage caused by the production and maintenance of the eastern border perimeter, we also conducted satellite imagery analysis from 1985 to 2018.[111] Using an archive of 2,924 optical satellite images, we calculated the maximum greenness for each year across the Gaza Strip in over three decades of military occupation.

The findings revealed the severity of vegetative degradation in the area, indicating that the areas that completely lost vegetation were mostly in the Gaza Strip, while the areas that have become greener over time, with increased vegetation, occur mainly on the Israeli side of the perimeter. Further, when following the known path of target areas for herbicide spray along the border, we were able to observe that the areas closest to the border display vegetation degradation similar to that observed in Khan Younes.

Additionally, when collecting a sequence of satellite images of cloud-free imagery as close to March of each year, the height of the growing season, and from the start of herbicide spraying in 2014 up to 2018, we were able to produce a compelling true-color visual showing the growth of the border over time.[112] Put differently, the past 30 years of satellite imagery makes the forced growth of the Israeli-imposed border onto Gazan territory literally visible. As a colonial construction, working according to a logic of racialized domination, the border grows only one way, encroaching onto Palestinian agricultural land, at each step becoming increasingly militarized and equipped with surveillance tools. The sequence of satellite maps shows Palestinian farms moving away from the border area, the border itself becoming increasingly defined, and the soil becoming increasingly bare and vegetation disappearing on the Gazan side—as a presumable result of

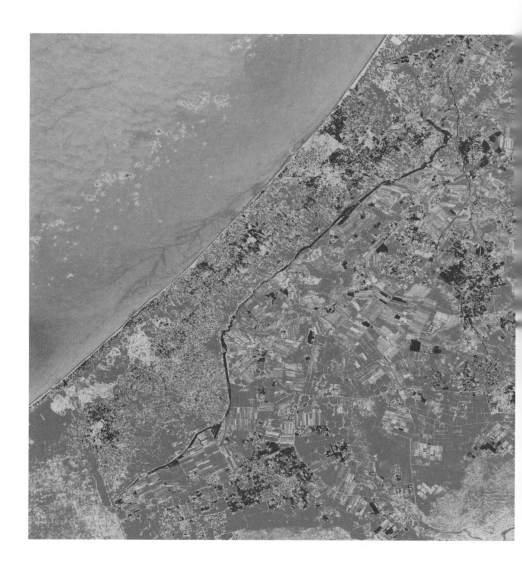

19. This map displays long-term changes to visual indicators of vegetation health across the Gaza region over the past three decades of Israeli occupation. Red indicates areas in which vegetation was completely eradicated. Vegetated areas that have degraded over time are shown across a gradient from yellow to red in order to illustrate the severity of degradation over time. Areas that have become greener over time are shown across a gradient of light to dark green and occur mainly on the Israeli side of the perimeter (Corey Scher for Forensic Architecture).

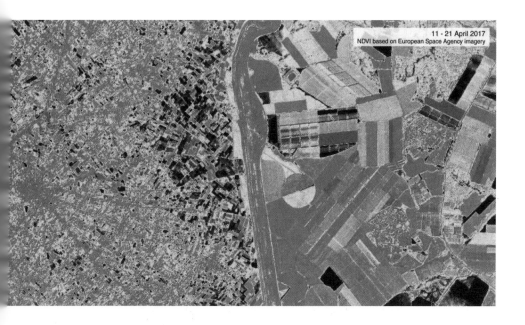

20. An NDVI analysis showing losses of vegetation between five days and 15 days after the herbicidal spraying. Red indicates areas in which vegetation has been lost (Corey Scher for Forensic Architecture).

herbicide spraying. The two-pronged colonial process apparent in these images, of the uprooting of formerly lush and rich indigenous Palestinian orange and olive trees taking place directly alongside the concerted planting and cultivation of farmlands led by Israeli-Jews during the same period fulfills the eco-colonial imagery of Israeli policymakers: a barren, neglected, and scorched indigenous landscape requiring domination and direction.

Of course, these techniques can only verify the colonial practices of Israeli environmental domination that Gazan farmers have been witness to, and which they have been documenting and resisting for the past four decades. These methods are useful in bringing to the front the testimony of the land as a silent witness to colonial violence. For example, the above aerial images using satellite analysis and remote-sensing reveal the environmental dimensions of Israeli settler-colonialism by showing a one-directional encroaching border onto Palestinian lands and a systematic damage to the land exactly along the Israeli-imposed border facing Gazan

21. Satellite images from 1985 (above) and 2014 (below) showing the loss of green areas, particularly in the Beit Hanoun area that housed Gaza's historical citrus industry, heightened urbanization, and the widening of a one-directional Israeli-imposed border into Gaza (Corey Scher for Forensic Architecture).

farmlands, among other violences. Taking this analysis further, they are also able to reveal the systematic practices of apartheid.

If we revisit the satellite analysis above that displays long-term changes to visual indicators of vegetation health across the Gaza region over three decades of Israeli occupation, we see sub-regions in Gaza experiencing 'stress' on the land—whether through tractor activity, the (over) grazing of land, the use of saline water, military attacks, or the aforementioned daily flattening by the IOF; to which herbicidal spraying has been added since. What immediately jumps out to the eye is that the north-eastern corner of Gaza, the formerly lush orange orchards of Beit Hanoun, are feeling particular stress as well as the central area of the strip. But from reading this map in reverse, the 'healthy' or 'non-stressed' areas of the occupied Gaza Strip also serve as bio-witnesses to the layered settler-colonial violence endured by the land and its people in this period. The green and yellow areas, lands that are not overused, have had access to clean and non-saline water, have not experienced repeated and systematic grazing, or bombings, seem to align in the form of a cross, dividing Gaza into four squares. These can reasonably be read as scars on the land of the *Pacification of Gaza* mentioned in Chapter 1, launched by Ariel Sharon decades before that systematically cut Gaza into four squares to enable military operations in communities in isolation. Should we overlay the former Jewish settlements prior to their unilateral evacuation in 2005 on the same analysis, we would observe visual scars of apartheid onto the terrain. This reading reveals how Jewish settlements were used infrastructurally to divide and penetrate Palestinian communities in the Gaza Strip, as well as how the lands where Jewish Israelis lived is, on average, and over the course of the three decades that were analyzed: largely 'healthier.' Here the Israeli practice of apartheid also becomes clear through the analysis of the terrain and the memory of cultivation and violence put forward by the land itself: the areas where one racialized community lives is 'less stressed' and exists in a relation of domination to the areas of another racialized and occupied community.

Considering these scars in relation to the work of architect and practitioner Paulo Tavares in the Ecuadorian and Brazilian frontiers of Amazonia on the historical memory of the earth itself brings forward an added dimension in our consideration of the extent of colonial violence. Informed by more-than-human approaches to heritage and memory, his term 'earthly memory' may be understood as a combination of composition and residue of accumulated practices and toxins over time—in the words of Hannah Mezaros-Martin, "a chemical architecture traversing water, air, soil and fatty tissues."[113] Thinking about our satellite imagery analysis of vegetation stress in Gaza as painting a landscape freighted with earthy memory in multiple ways, also invites

future considerations of a broadening of claims in the Palestinian liberation movement. As Mezaros-Martin notes:

> Through ongoing discussions around environmental truth and reconciliation, questions of representation arise: if it is accepted that the earth has its own memory—which can take on many forms—how can this memory be visually represented in a court of law or in a setting like a truth commission? And further, what does truth (and reconciliation) look like from the point of view of the earth? What kind of truths could a plant tell? Or the soil? Or the air? What sort of historical memory does the earth have and how can we read it? What kinds of aesthetics are called for when trying to document, and also resist, processes of enforced extinction? And how would this reorientate our idea of truth—including evidentiary truth?[114]

Looking from the perspective of non-human earth-beings, whether the soil, a plant, or the multi-species on whose ecosystems human survival is dependent, also calls for a new grammar and annunciation of rights and experiences. Indeed, it is in these moments where high-tech analyses and tools representing the intertwined and multi-formed lived experiences of violence can open the discussion on ways to confront and address colonial practices of environmental domination and erasure.

Conclusion

Sowing new landscapes of resistance

A walk along the border

On 15 May 2011, inspired by the Arab Spring, Palestinians in the occupied Gaza Strip, West Bank, Jerusalem, and along the borders between Syria and Israel (Golan Heights) and Lebanon and Israel (Maroun al-Ras) initiated mass civilian protests to commemorate 63 years of *Nakba*. Marching by foot toward the borders, thousands of women and men, secular and religious, young and old, and from a range of working and creative classes called for their legally enshrined Right of Return, as affirmed in the United Nations Resolution 194. These non-violent civilian demonstrations were brutally repressed by the Israeli occupation forces, killing dozens near the Syrian and Lebanese borders as well as in Gaza and injuring over 170 persons.

Seven years after these inspired marches, commemorating 70 years of *Nakba*, Palestinians living in the besieged Gaza Strip organized to revive the peaceful marches as a tactic of mass resistance. Named the Great March of Return and the Breaking of the Siege, the idea was initiated by Palestinian poet and writer Ahmed Abu Artema from Gaza, who posted on Facebook the idea of a non-violent march at the border. Walking with friends along the border perimeter in the East of Gaza one evening, one of the few areas of Gaza where most Palestinians retreat for open space away from the commercial bustle of traffic in Gaza City, Ahmed was moved by the sight of birds above him, flying freely across the flattened border with no regard to the military infrastructure, political constraints, and physical barriers that confronted Palestinians in Gaza. Expressing his thoughts online sparked many responses and discussions and soon after the idea for an independently initiated mass non-violent refugee-led protest took rise among a group of independent persons with Ahmed, with the aim of returning refugees to their homes across the Israeli-imposed perimeter zone.

Organizers sought to instill unity and collaboration by harnessing support from Palestinian civil society and reached out to bring political factions on board, while clarifying that the initiative was not limited to any one political contingent. While the previous marches of 2011 were inspired by the Arab Spring, these demonstrations were growing out of 50 years of occupation, decades of siege and political infighting, including damage from three major Israeli invasions in 2008, 2012, and 2014—all of which led to massive socio-economic and infrastructural destruction in Gaza,

with record-setting unemployment rates and high poverty. Added to this reality was the decision of the Trump administration to unilaterally declare Jerusalem as the capital of Israel, as well as reducing US support to UNRWA. Together, Palestinians in Gaza felt a sense of existential urgency to confront their isolation and confront these direct attacks against the Palestinian refugees' Right of Return.

The nature of the mass action also reflected the eco-political realities on the ground. Organizers were pragmatic having lived first-hand the international political and military imbalance between the Israeli occupation forces and Palestinian liberation movement and adopted the language and practice of peaceful and unarmed protest. Further, the flattened terrain, rid of trees, entire orchards, and residential homes that resulted from Israel's eco-colonial maintenance of the border practically invited a march as a tactic. Standing hundreds of meters away from the metal fence that marks the Israeli-imposed eastern periphery of Gaza, Palestinians could see the lush orchards tended to by Israeli farmers inside 1948-Palestine—lands they are prevented from accessing. One of the organizers of the Great Return protests told me: "From Gaza we can see our villages, we can see the settlers living on our lands, so we march." Put differently, the tactics adopted in the *Great March* on the eastern periphery were, in large part, shaped by the eco-colonial landscape created over time by the occupation.

With the Right of Return as the political anchor to these protests, organizers built tents along the border, including at East Rafah, Khan Yunes, Khuza'a, East Bureij, East Jabalia, and Abu Safiya, all about one kilometer away from the eastern perimeter. The tents were labeled, named after destroyed and depopulated villages of Palestinian refugees. And on 30 March 2018 on *Land Day*, the protests were officially launched with the aim to continue, each week on the Friday, until *Nakba Day* on 15 May, and beyond if needed, until the demands were met: return of Palestinian refugees and end to the siege.

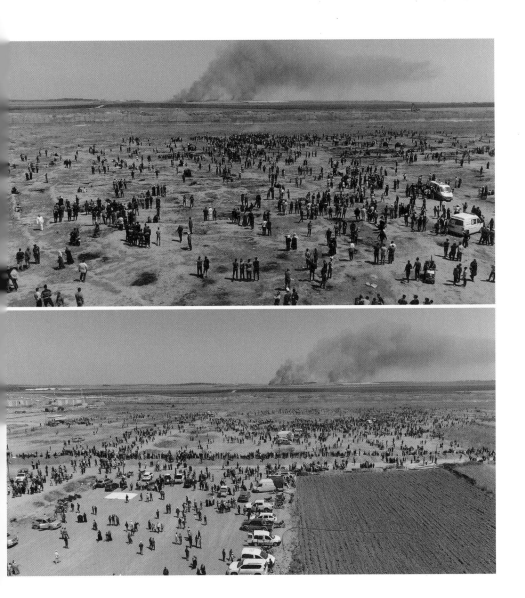

22. Stills of drone footage of the *Great March of Return*. The flattened perimeter inspired Palestinians in Gaza to adopt the tactic of marching by foot to their former villages. To push back Palestinians from returning, Israeli occupation forces used drones to unleash teargas onto protesters (Ain Media Gaza and Shourideh C. Molavi, 2019).

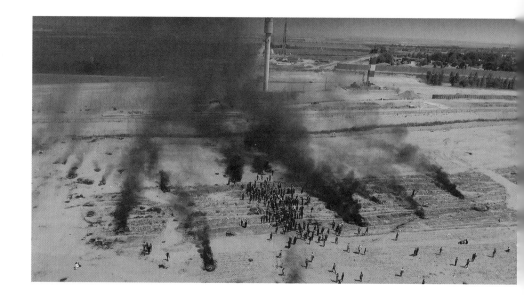

23. Stills of drone footage of the *Great March of Return*. The flattened landscape enabled occupation snipers a clear line of sight to hundreds of Palestinian protesters, who, in turn, strategically burned rubber tires to block their visibility (Ain Media Gaza and Shourideh C. Molavi, 2019).

The otherwise flattened and scorched border areas, lands where previously orange and olive trees stood, were activated socially, culturally, and politically. Cultural and recreational activities such as folk dancing, collective reading, children's entertainment and games, arts and sports activities, mass prayers, and cooking of traditional foods were conducted on the perimeter as an act of defiance, return, reclamation, and steadfastness. With this, the divide between the Gazan rural and urban life collapsed during these protests. Middle classes from the cities traveled to the eastern perimeter to join these collective gatherings, often with their children for picnics and family entertainment.

In coordination with the main political factions in Gaza, *Hamas, Islamic Jihad,* and the *Popular Front for the Liberation of Palestine,* organizers ensured in those early weeks that these gatherings would continue along with protests, without the eruption of violent confrontations near the Israeli military along the border. Seeking to garner worldwide support and visibility, organizers also created the independent national committees to

24. Stills of drone footage of the social and cultural life built along the eastern perimeter of Gaza during the Great March of Return. The flattened perimeter was activated as a space of artistic and economic production, with tents signifying the loss of lands and the right of return, and frequent communal gatherings such as mass prayers that complemented the protests (Ain Media Gaza and Shourideh C. Molavi, 2019).

manage activities in the camps in coordination with the political factions, with the collective agreement and prerequisite that only Palestinian flags would be displayed in the protest camps to signify Palestinian unity. And in a historic step toward unity, they were successful.

Night confusions

On *Land Day*, a wide range of the Palestinian public attended, along with civil society organizations, religious associations, community members, and all major political factions, even including Fatah. The perimeter was now activated as a place of political and cultural production, a place of respite from the dense and noisy city center, and brought Gazans physically closer to Jerusalem, to villages lost in 1948, and to the rest of the Palestinian nation in the country. Many participants recounted to me that whereas in the past they would never travel to the eastern periphery of Gaza for fear of Israeli snipers in the 'access-restricted areas' the marches provided a type of safe cover allowing them to get closer than before.

A sense of renewed agency, and hope, took over in this period with individuals and groups inspired by these successes and commencing to starting their own events and activities along the perimeter. For example, the creative tactic of 'night confusions' was inspired by the marches. A night confusion has two parts. The first takes place about an hour before sunset when young men attach an incendiary device to a helium-filled balloon. While in the mornings the wind blows toward the west—and was thus mobilized by the IOF as part of its mentioned herbicide sprayings—at this time of the day, the wind blows from the west to the east. Mobilizing the wind as part of their resistance, groups of mostly young men, though also some women, release the balloons into the sky, leaving the wind to carry them into Israel, and onto Israeli-controlled farmlands. From there, a second stage of confusion ensues with fireworks attached to the balloons. A similar use of the wind was conducted by a group called the 'kite brigade,' unleashing dozens of incendiary kites into Israeli-controlled lands to damage these agricultural sites and hamper the normalized life of communities living directly adjacent to the occupied and besieged Gaza Strip. Planned carefully and discussed collectively, these acts of resistance functioned within the means of its initiators, using relatively inexpensive and easily accessible and replicable materials, and are a direct response to the environmental reality created over time with the uprooting of trees and flattening of the land along the eastern border.

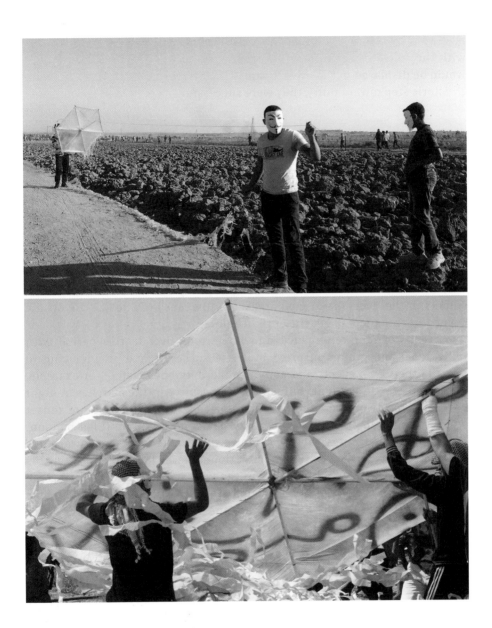

25. Incendiary balloons and kites flown by Palestinian protesters in Gaza who mobilized the wind into Israeli-controlled lands to set occupied farmlands along the eastern perimeter on fire (Ain Media Gaza, 2019).

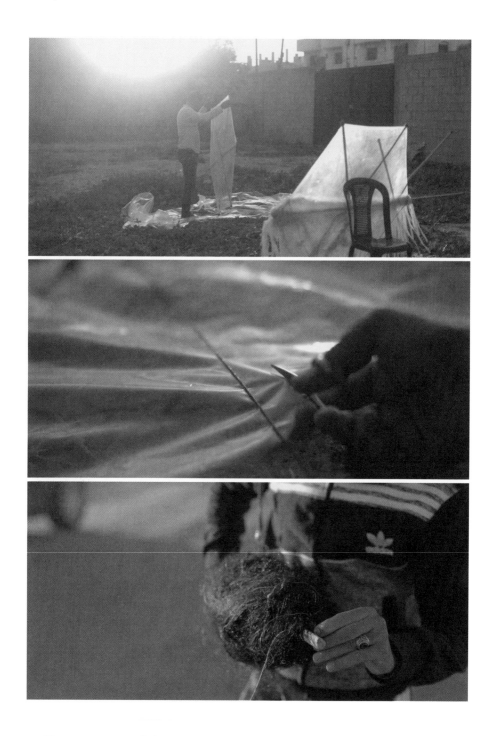

26. Khamees, a young father and protester, showed us his techniques for constructing a kite (Ain Media Gaza, 2019).

With the success of these protests, political groups like *Hamas* sought to mobilize the momentum gained to empower their authority locally, crediting themselves in the press for the marches. In fact, as a leaderless mass movement, it included factions like *Hamas* who participated in these actions like any other political grouping of Palestinian society, without any exclusive decision-making power. As a tactic, the mass civilian marches were seen as a long-term strategy, political in nature, but with creative and cultural outputs that spoke to a broader range of local and international observers.

Unsurprisingly, these acts of resistance, whatever their form, were repressed by the Israeli occupation forces. Whether through the launching of teargas using drones or targeted sniper killings from a distance of both protesters and visible press, multiple forms of repression were applied by the IOF to push back the march of returning refugees away from the eastern perimeter. Ahead of the *Land Day* march, and in particular leading up to the *Nakba Day* anniversary when protests were anticipated to be larger and more intensified, the IOF placed tanks, military jeeps, and established sniper posts all along the Eastern perimeter, directly facing the protest camps. Despite efforts by organizers to push forward mass actions that were peaceful or non-violent in nature, some protesters also marched to the Israeli-imposed perimeter and burned tires. The burning of tires deserves special attention here because that too was an act of creative resistance. The flattened 'buffer zone' and the notable absence of trees resulted in full exposure and visibility for strategically placed and trigger-happy Israeli snipers. And so, to impede their visibility and literally offer a cloud of protection from the gaze of the sharpshooter, Palestinian protesters set tires on fire. That smoke, while itself of course extremely toxic, also helped weed off the sting of teargas, massive amounts of which were unleashed on protesters.

That smoke, while itself of course extremely toxic, also helped weed off the sting of teargas, massive amounts of which were unleashed on protesters. The confrontation between the toxic smoke of resistance from Palestinian protesters and the colonial toxins of the IOF's drone-deployed teargas brings to the forefront the reality that breathing is more than simply a biological necessity. The "commonality" or shared dependence on breath, as Achille Mbembe reminds us, pushes an entry into politics from the perspective of the breathless—of the economy of suffocation that colonial projects produce.[115] Here too, the commonality of the lungs of indigenous communities and their lands is also revealed: assault against the lungs of Palestinian communities in Gaza is interlaced with the concerted attack against their orchards, their sea, and their vegetation.

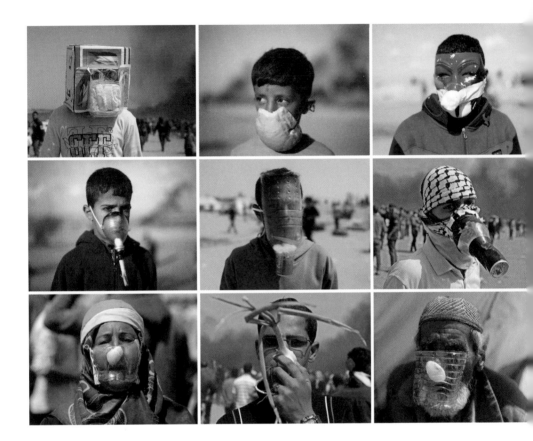

27. Photos of creative masks used a by Palestinian protesters in the Great March of Return to protect from vast amounts of teargas sprayed by the Israeli occupation forces using drones. During the publication of this book, in September 2023, the photojournalist who documented these masks, Ashraf Amra, was himself directly hit with a teargas canister shot by the occupation forces while standing around 350 meters from Gaza's eastern perimeter and covering the ongoing weekly civilian protests (photos by Ashraf Amra, 2018).

Fast violence: Targeting Palestinian bodies as a national body

Preparations for the mass protests on 14 May, the date of the move of the US embassy to Jerusalem, and 15 May began weeks before. On the 14th, the world watched live, on most mainstream news channels, a split screen of American and Israeli political elite celebrating the move of the embassy in opposition to international law and opinion on one side, effectively sealing shut the possibility of the US supporting Palestinian calls for statehood in any tangible way, and on the other masses of Palestinian civilians marching by foot toward their former villages from the occupied Gaza Strip. Brutal force and live ammunition were exercised by the IOF on marching civilians—including clearly identified journalists, health workers, children, and persons with disabilities—killing at least 154 Palestinians, including 35 children in 2018 alone.[116] The Israeli army also injured 6,000 Palestinians using live ammunition, including 940 children.[117] This despite the overwhelming international consensus that the protests were civilian in nature. Indeed, the UN Commission of Inquiry launched later on the protests reported that "the demonstrations were civilian in nature, had clearly stated political aims and, despite some acts of significant violence, did not constitute combat or a military campaign." It went on to state that Israeli soldiers "committed violations of international human rights and humanitarian law," and that "some of those violations may constitute war crimes or crimes against humanity."[118]

Here an unnamed policy of maiming by the IOF took force. The slow 'desertification' of a once lush and agriculturally active border zone provided the Israeli army with this visibility from a distance enabling the maiming of tens of Palestinians, mostly young men. One in five of those injured were struck by live ammunition, and the overwhelming majority of those injured by live ammunition experienced limb injuries. Indeed, the UN Commission's report, Médecins Sans Frontières, Amnesty International, Defence for Children International all documented that severe wounds among Palestinian civilian demonstrators in Gaza were caused using high-velocity munitions by Israeli snipers. With a suffering healthcare system under siege, over 100 amputations were required in Gaza for these limb injuries, and many required secondary amputations resulting from bone infections.[119] The slow violence of spatial degradation through the mobilization of environmental elements accelerated into an eruptive violence with life-long psychological, physical, economic, and social implications for a generation of young Gazans.

Beyond the immediate incapacitating of the protestor, injury and amputation have far-reaching implications. Indeed, leaving the defiant Palestinians alive allows Israel to maintain its perpetual presence in their lives through 'a young Palestinian generation walking on crutches.' A study on Palestinian amputees in Gaza found that most were young [...] and educated. Sixty-three percent were the main breadwinner in the family before the injury. Most of them (85%) suffered a major amputation above the knee and reported long-term pain. Long-term ramifications were observed in their own and their families' lives. Amputees reported physical and psychological problems in relation to their limb loss, with pain being the most common one; half reported being unemployed due to their disabilities, thus bringing new burdens to them and their families.[120]

The number of amputees was so pronounced after these protests that in December 2021, Palestine's first-ever amputee football team was launched in Gaza City, coinciding with the *International Day for People with Disabilities*.

In this period, I also supported an investigation conducted by Forensic Architecture and Praxis Films led by filmmaker Laura Poitras into the Safariland Group which started at the Whitney Museum of American Art in New York City and, in the end, brought us to the same eastern perimeter in Gaza where I had been working with farmers experiencing herbicidal warfare. The investigation followed the corporate links of Warren B. Kanders, Vice Chair of the Whitney Museum of American Art and CEO of the Safariland Group who was also the Director and Executive Chairman of the Clarus Corporation, which had purchased the manufacturer Sierra Bullets in 2017. We examined the type of live ammunition used by the IOF to suppress the protests along the Gazan 'border' and, through open-source research, were able to identify IOF soldiers carrying both M24 and SR-25 rifles.[121] The report by Forensic Architecture stated that:

Stanford's Dr. Gary K. Roberts suggests that the Match King bullet used in the M118LR round is prone to breaking up or fragmenting following entry into soft tissue and can "exit the target and pose a significant downrange hazard to innocent bystanders." According to Parks, the M852 round, which features a MatchKing bullet, exhibited a tendency to break up at close range during testing. An unofficial Guide to US Special Forces makes a similar claim, that the M852 would sometimes "break up or fragment following entry into soft tissue." Among other factors, higher velocity at the time of impact increases the likelihood of fragmentation inside the body.[122]

Our concern for the types of bullets used was shared by the medical workers in Gaza with whom I spoke—many of whom believed that expanding, or 'dum-dum' bullets were used against protesters based on the type of injuries they observed. A Palestinian doctor at Al-Awda Hospital in Jabaliya described in March 2019 the kind of severe injuries endured by protesters due to live ammunition, saying that, "From the shape of the injury [and from] the little pieces of the bullets we can tell that they are not normal bullets. The exit holes are bigger with more bleeding and more damage."[123] Later in April 2019, a Palestinian doctor at Shifa Hospital in Gaza City shared this x-ray of an injury sustained by a protester in December 2018 during the *Great March*.

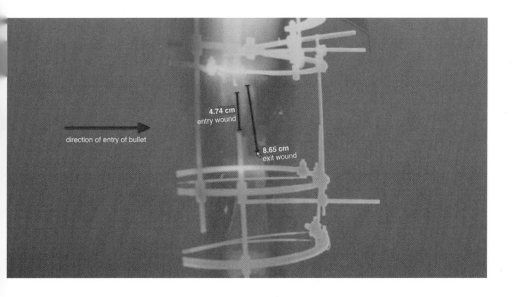

28. X-ray with annotations showing difference between the size of the entry and exit wounds that according to the report of the UN Commission was indicative of high-velocity ammunition (Source and annotations by: Forensic Architecture/ Shifa Hospital).

The doctor continued to explain that:

> Most of the patients we received had fractures that were not from normal bullets. Normal bullets make a simple fracture [...] But what we have is an explosion of the bone with [...] great damage to the soft tissue [...] Sometimes we had three people hit, one after the other, from one bullet. One bullet, three people.[124]

Another doctor with whom I spoke from the Indonesian Hospital in Gaza City, Dr. Basel Alaila, explained that:

> The types of injuries we are used to seeing normally result from 5.56 bullets used by the army. These bullets also do damage but not like the severe injuries we have witnessed from the bullets used during the protests [...] This bullet is more dangerous than the live bullets normally used [...] it breaks into many sections that can hit various organs and cause bleeding, which may lead us to remove the organ. These types of wounds often leave the surgeon in Gaza with very little choice; all bad choices.[125]

Despite these suspicions, we were unable to identify any material evidence of the use of 'dum-dum' bullets, projectiles designed to expand upon impact. Instead, through the help of medical and ballistics experts, Forensic Architecture was able to determine that the use of otherwise 'legal' or 'normal' bullets designed for 'long-range accuracy' at a close range could both cause injuries reminiscent of expanding bullets and, significantly, also "exhibited a tendency to break up at close range during testing."[126] In effect, the use of so-called 'normal' or 'legal' bullets in a manner that produced significant injury and lethal consequences was a direct result of the eco-colonial production of a flattened eastern periphery, enabling Israeli snipers to shoot at civilians from a short distance without impediment, and with a clear line of sight.

The brutal violence of direct targeting using live ammunition was suspected by many participants on the ground to be the main reason why the protests on *Nakba Day* in 2018 were not as large as was expected, given the mass trauma, mourning and confusion caused. Organizers called for an extension of the weekly marches to 5 June, the *Naksa* or 'setback' in Arabic referring to the 1967 war when the rest of Palestine, including Jerusalem, the West Bank, and Gaza Strip was occupied, but those gatherings did not carry the same momentum given the eruptive violence of targeted shooting by snipers.

Despite these setbacks, the *Great March* brought to the political forefront the unnegotiable issue of the Palestinian Right of Return, adding global visibility to the commemoration of the *Nakba*. These weekly gatherings also provided the template for Palestinian political unity, broad-based organizing, and national solidarity around a single topic—here being the loss of Jerusalem as an ongoing *Nakba*—all despite fragmentations caused by Israeli restrictions to movement via permit systems, the construction of checkpoints and the separation wall.

Gaza's eco-political landscape of resistance

The start of 'Operation Al-Aqsa Flood' on 7 October 2023 by the military arm of *Hamas* mobilized the eco-colonial landscape that formed Gaza's scorched periphery. Fighters crossed the flattened 'border' terrain by foot, and like the kites that were flown during the *Great March* years before, they openly flew across one of the most intensely surveilled parts of the country on paragliders. From there, the infrastructure of the occupation was taken apart: observation cameras were shot at, communication towers were attacked, and with bulldozers the double-wired fences that surrounded the engineered boundary of the Gaza Strip were breached and cut open. As one of the largest episodes of Palestinian resistance in decades, the uprising fully surprised the Israeli military establishment and defence analysts around the world: even if for a short while, Palestinians were able to break free from their prison in Gaza, many being refugees returning to their depopulated villages. At the time of writing, the uprising is still ongoing: rockets continue to be fired from Gaza and a horrendous bombardment by Israeli ground and air forces has been unleashed—with genocidal policies in full practice where fuel, water, food, electricity, and other aid are systematically and openly withheld from almost 2 million besieged Palestinians in an act of collective punishment. While there is much to unpack and mark in the ongoing events—including the ramifications for Palestinian liberation, the need to interrogate the Western and European discourse of 'human rights,' 'women's rights', 'environmental rights', and the 'right to have rights', and its effects on the geopolitics of the region more broadly—the ongoing uprising is in both form and content a reminder of the ways in which settler-colonial violence manifests itself.

In its essence, settler-colonialism *is* the formation of new ecologies. In thinking of an ecology as a set of entangled relationships—a system of human interaction with landscapes, terrains, and non-human beings—the violence directed against the land and the ecosystems that inhabit it also gives shape to the decolonial tactics and strategies that are mobilized. Put differently, new terrains of warfare induce new landscapes of resistance. In

the case of Palestine, as the most visible sign of presence, ownership, culture, and resilience protecting farmers and communities from expropriation, *trees* have become particular targets of the Israeli occupation. The slow but steady eco-colonial production of Gaza's scorched periphery has made this painfully visible. But the hundreds of meters of flattened land enabling Gazans clear sight of lush and well-supported farmlands across Israel's hyper-militarized fence is also a physical reminder that the colonial impulse that led to the *Nakba* over seven decades ago continues to be at work. Whether ongoing home demolitions, land expropriation and confiscation of property, depopulation of 'unrecognized' villages, imposed planning restrictions, or the targeting of civilian infrastructure—these practices are also all forms of environmental domination and control. While not as eruptive as the mass expulsion of hundreds of thousands, it is the same eco-colonial imperative of restriction, reduction, and erasure of indigenous Palestinian presence and capacities that fuels the Israeli production of the present Palestinian landscape. In so doing, and as witnessed with the 7 October uprising, this landscape shapes people's consciousness of the possibilities available for their present eco-colonial terrain to be activated in the interest of *return*.

Yet, at the same time, in a global trend of industrializing agricultural land, the multifaceted violences faced by farming communities in Gaza are not unique: indigenous agricultural societies all over the world are targeted by sovereign efforts to dispel their sustainability and autonomy over food production, and increase their dependency on multinational corporations, state assistance, and agri-business firms. But what sets Gaza—and Palestine more broadly—apart is the ways in which this intersection between power and environment that is at the core of the global ecological crisis is inter-laced with the tenacity of present-day and hyper-militarized Israeli settler-colonial and apartheid practices and policies. Israeli eco-colonial practices along the eastern 'border' against historical orchards have brought together Palestinian agricultural society as well as its urban community and military factions in their respective resistance strategies. Multiple aggressive attempts and policies to practically eliminate the power of Palestinian farmers by cutting their access to the land, alongside the systematic flattening of Gaza's peripheries and the steady nurturing of its ever-present socio-economic and cultural siege has created moments that collapse the demands of urban and rural, and helped focused the tactics available to Palestinians across social classes. While it remains unclear how the Israeli-produced eco-imaginary of the Gazan landscape will continue to be mobilized in the ongoing indigenous liberation struggle, as long as this desire, conscious and tacit, to create a settler ecology out of the ecology of Palestine continues, novel and subversive frontiers of resistance to confront it will also continue to blossom.

Acknowledgments

The idea for this book started with an examination of the disappearing trees of Gaza, focusing on the forgotten historical citrus industry that existed along the eastern 'border.' From there, the study evolved into an investigation with Forensic Architecture, a research group based at Goldsmiths, University of London, into herbicidal warfare during the Israeli occupation along the same border area. As the research continued the interlacing of the slow violence that flattened this terrain with the eruptive violence of the occupation forces to suppress Palestinian resistance from a distance became evident during the 2018 Great March of Return and the Breaking of the Siege and again most recently during the tactics mobilized in the uprising launched on 7 October 2023. Together, these elements form the corpus of this book, as a combination of forensic evidence and methodologies infused with a human texture that centers the discussion around contemporary practices of Israeli colonial eco-imaginaries in Gaza and the landscapes of collective struggle that emerge today.

The findings and experiences shared here are a culmination of dedicated fieldwork I conducted between 2016 and 2019 in the occupied Gaza Strip in Palestine. With the privilege of a permit and repeated first-hand access— whose difficulty in attaining is obvious to any observer of the Israeli occupation—I traveled to Gaza on four separate occasions during this period. Entering through the Erez checkpoint, I met with the Ministry of Agriculture (MOA) in Gaza City, conducted interviews with Palestinian farmers and former leaders in Gaza's now-erased citrus industry along the imposed border, and worked in close collaboration with the *Union of Agricultural Work Committees* and the *Al-Mezan Center for Human Rights*.

For those outside of Israel's apartheid categories of inclusion and unrestricted movement, travel to and from Palestine is extremely difficult, humiliating, and physically and emotionally straining. In my case, despite having received all colonial permits and clearances beforehand, each entry and exit involves an average of 6–10 hours of interrogation by the Israeli occupation authorities. To paint the picture, and with full knowledge of my privilege of access: on each of these trips to Gaza, I crossed nine different border checks, each with their own permit requirements and sets of questions, all in a single day, and within strict time restrictions due to Israeli closures and checkpoint restrictions. These restrictions are of course incomparable to those faced daily by Palestinians. Upon entry into occupied Gaza, extensive coordination is also required to ensure smooth movement within the strip, as well as access to the high-risk border areas where the

herbicide spraying is conducted by the Israeli army and affected Palestinian communities are located.

For these and many other reasons, this book would have been impossible without the intellectual generosity, personal risk, and political commitment of the colleagues, allies, organizations, activists, and dear friends in Palestine who generously supported me on the ground—sometimes under extremely difficult circumstances. These include most significantly Shurouq Alaila, Roshdi Al-Sarraj, Samir Zaqout, and Issam Younes, friends and loved ones without whom I would be lost in Gaza. Deep thanks and gratitude go foremost to the dozens of farmers, in particular Adham in East Jabaliya and Mona in Khan Younes, for their trust and the sharing of their expertise and knowledge of cultivation practices, as well as to the team of researchers at the *Al-Mezan Center for Human Rights*, the Gaza Ministry of Agriculture, Mohammad al-Bakri and the *Union of Agricultural Work Committees*, Mr. Faisal al-Shawwa of the *Al-Shawwa Beit Hanoun Gaza Citrus Export Company*, the film crew at *Ain Media Gaza*, the Tel Aviv-based *Gisha: Legal Center for Freedom of Movement* and the Haifa-based *Adalah Legal Center for Arab Minority Rights*. Warm thanks also to Islam Ahmed, Metodi Pachev, and Ofer Neiman for their support. During my research, I regularly met with lawyers, fieldworkers, and advocacy teams in these organizations to discuss the parameters of the investigation into herbicide spraying, and visited both *Katif Center Laboratories* in Netivot, and *AminoLab* in Ness Ziona to speak with representatives from the Pesticides and Mycotoxins Division about the sampling and testing of leaves for herbicide damage.

Once the research on eco-colonial violence in Gaza was collected—including dozens of leaf samples, first-hand videos of herbicidal spraying, photographs of damaged crops, hours of testimonies by affected farmers, archival images and maps, as well as historical documents, among other previously unattained material evidences on this topic—I worked closely with these friends and collaborators and a committed research team at Forensic Architecture, to cultivate the terrain of our investigation. Together we determined the destructive signature of herbicide spraying events, the nature of the environmental elements mobilized in their scorching of Palestinian lands, and threaded together the material evidence I collected in Gaza with farmers, with information derived from a distance analyzing the vegetation on the ground. Special thanks to this team, including Dr. Samaneh Moafi, Dr. Salvador Navarro-Martinez, Corey Scher, Stefan Laxness, Grace Quah, and Sarah Nankivell for their support and the sharing of expertise to make this investigation possible.

An intellectually generous friend with an unparalleled gaze, I owe deep gratitude to Eyal Weizman, Director of Forensic Architecture, for his close guidance and well-intentioned *kvetching* throughout this learning and

writing process. Eyal gave me space to take this project forward, break some rules, and move at my own speed. Years spent thinking with my dear friends Sandi Hilal and Alessandro Petti in Palestine were also central to sparking my initial interest in the history of oranges in Gaza and the possibility for this history to inform present-day and urgent decolonial pedagogies for liberation.

I am also full of gratitude to all the people with whom I have built deep friendships, relationships, and collaborations over these years, for their inspiration and dialogue when learning from Palestine across the dividing borders. For their feedback in linking eco-colonial violence in Palestine to Sicily, Egypt and across the militarized Mediterranean, special thanks to Sergio Sanna, Pier Francesco Pompeo, Iman Hamam, Jens Haendeler, Niloofar Golkar, Francesca Gattello, Zeno Franchini, Valentina Sansone, Roberto Albergoni, Lisa Wade, Emilio Distretti, and Kenny Cupers. And for their invaluable political insight, friendship, and support of my work in Palestine over the years, I am deeply grateful to Laura Poitras, Shokoufeh Sakhi, Hazem Jamjoum, Ahmad Amara, Chowra Makaremi, Amira Hass, Ashraf Hamdan, Rula Shadeed, Shawan Jabarin, Azmi Bishara, Ana Naomi de Souza, Thomas Keenan, Laura Kurgan, Ines Weizman, Yazid Anani, Andrew Delatolla, Mazen Masri, Pelin Tan, Shaden Awad, Raji Sourani, Hassan Jabareen, and Suhad Bishara. Warm thank you also to my editor David Shulman for his thought and care through the writing and publication process. Although an incomplete list, it is a reminder of the deep relationships that underpin and continue beyond the research.

Not least, my eternal gratitude and love to Parvin, Behzad, and my new extended family, Andrea, Delizia, and Marcello for all their support and care as I learn to juggle motherhood and politics—and, of course, to Tiyam, love of my life, for her patience.

Tribute to a loved friend:
Roshdi Yahya al-Sarraj (1992–2023)

There are moments to write as a forensic researcher, and moments that demand we speak as a grieving friend. On 22 October 2023, during arguably the most horrific Israeli onslaught against Palestinians in Gaza since the mass depopulation of the Nakba that began in 1947, I received devastating news that my friend and collaborator, journalist and co-founder of *Ain Media Gaza*, Roshdi Yahya al-Sarraj, was killed after an airstrike on his family home by the Israeli occupation forces. His wife (now widow) Shurouq Alaila told me that they were having breakfast together when their home was bombed, Roshdi throwing himself on her as a shield.

Weeks prior to Roshdi's killing, *Ain Media* had already lost one member, cameraman Ibrahim Mohammad Lafi who was killed covering the Gaza

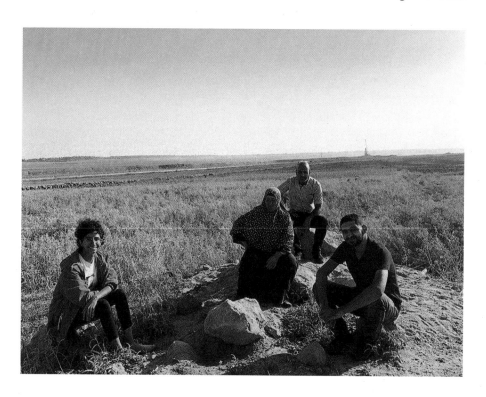

29. One of our final site visits together to the farmlands of Muna, a well-known Bedouin farmer and organizer, also accompanied with Mohammad Azaiza from Gisha in East Gaza, September 2019. (Shourideh C. Molavi, 2019).

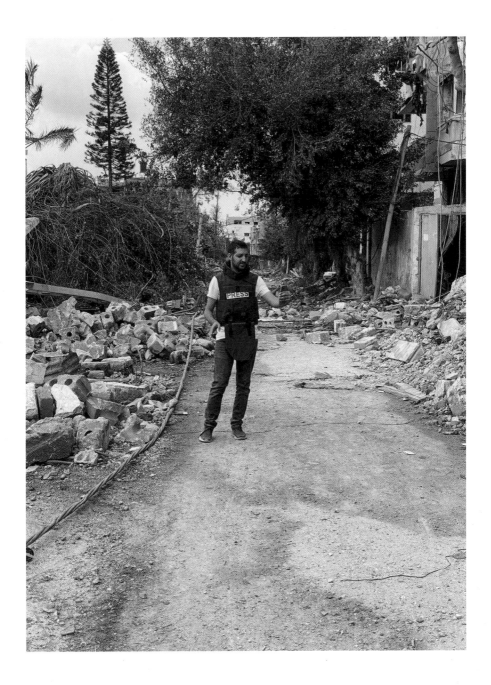

30. One of our final images of Roshdi as he documented the devastating Israeli attacks in Gaza City during the war (Roshdi Yahya al-Sarraj, Instagram, October 2023).

Strip's Erez Crossing on 7 October. We at Forensic Architecture were analyzing available footage to determine the fate of two other friends and cameramen, Nidal Al-Wahidi and Haitham Abdel-Wahed who had accompanied Ibrahim at Erez. All three of them were wearing PRESS vests and holding cameras at the time, and at the time of writing Nidal and Haitham remain missing.

I first met Shurouq and Roshdi in Gaza in 2016 when researching the 'disappearing' orange orchards in Gaza—the initial research that gave birth to this book. The two met and later fell in love with each other through that project. They married in September 2021 and had a little girl, Dania, in November 2022. I will not here share photos of this gorgeous child, but only write that she has her father's eyes.

With Shurouq and Roshdi, and supported by their team at *Ain Media*, I worked on producing numerous unprecedented projects in Gaza. In 2017 and 2018 we collected the leaves of the scorched crops along the Israeli-imposed border of eastern Gaza that are shown in this book, meeting dozens of farmers whose livelihoods were destroyed by Israeli herbicidal warfare. The 'border' areas to the east became more familiar to us, as we spent many weeks walking along its flattened terrain. Together we learned to understand trees and crops as political subjects in Palestine, and the need to incorporate documentation of the violence against the land into our lexicon of historical injustice.

In 2018, Roshdi and Shurouq worked with us at Forensic Architecture to document Israeli sniper fire and conduct photogrammetry analysis of the likely use of Sierra bullets by the IOF at the civilian protests at the Great March of Return. I remember Roshdi reeling from the loss of his best friend and Ain Media co-founder, 31-year old Yasser Murtaja, who was fatally shot by an Israeli sniper on 6 April despite also wearing a flak jacket with clear PRESS markings. With this friends and colleagues, Roshdi rebuilt *Ain Media* in Yasser's enormous absence, in defiance of the pressures of the Israeli-imposed blockade and having to navigate the ad-hoc restrictions of both the local government in Gaza and the Palestinian Authority.

Later in 2019, and against all odds, Roshdi and his team filmed the Shaati beach to support Forensic Architecture's modelling of a site of Gazan cultural heritage destroyed through both coastal erosion and the humanitarian disaster produced though Israel's decades-long occupation. There are many other examples of ground-breaking projects Roshdi worked on that I can list here to honor our lost comrade. Films that we have made together, yet to be released. Shurouq and Roshdi are two of my best friends in Gaza—two of my main reasons for hustling and haggling with all of the corrupt authorities to get a privileged permit to enter Gaza. And it is the people in Gaza that give its stones and its sea their meaning.

As he rebuilt *Ain Media* after the loss of Yasser in these years, Roshdi also cultivated a life with Shurouq, finally receiving his Palestinian travel document to travel outside of Gaza together, and slowly building their new home on the sea—a place where Roshdi recounted many times his eagerness and joy to start his family. Like thousands of other attacks against Palestinians that have occurred since the start of the uprising on 7 October 2023, Israel has neither denied killing Roshdi nor given any excuses. Roshdi was not killed as a journalist documenting colonial violence on the ground like his colleagues, he was killed sitting around the table with his wife and child, soaking in precious moments of togetherness in between the shrieks of Israeli airstrikes, in the confines of their home. His killing will not receive attention in mainstream papers and forensic studies will not be done by competing authorities about who fired what from where, how or why. Instead, hundreds in Gaza and around the world who were lucky to know Roshdi in this life will privately mourn the excruciating loss of their friend and comrade, and collect stories of him to share with Dania when she is older.

When the 7 October uprising started, Shurouq and Roshdi had just arrived in Mecca, Saudi Arabia, with their daughter. They changed their plans and returned to Gaza the next day via Rafah to cover this historic moment in the Palestinian liberation movement. Growing up in Gaza and tasting previous Israeli wars, Shurouq and Roshdi knew the bloodshed and destruction that would unfold but returned anyway. Young, in love, talented, accomplished Palestinians with a child would rather come to Gaza to resist, document, and defend their homes than to live abroad. And if only for such principles and commitments, it is clear that at the end of this struggle Palestine will be free.

Notes

1 A.M. Qattan Foundation, *Weed Control*, "Curatorial Statement," Exhibition, Ramallah, Palestine, 2020.

2 Kyle Whyte, "Settler Colonialism, Ecology, and Environmental Injustice." *Environment and Society*, 9, 1 (September 2018): 135.

3 Ibid.

4 J.M. Bacon, "Settler Colonialism as Eco-Social Structure and the Production of Colonial Ecological Violence." *Environmental Sociology* 5, 1 (2018): 61.

5 Patrick Wolfe, *Settler Colonialism and the Transformation of Anthropology* (London: Cassell 1999).

6 Among others, see Patrick Wolfe, "Settler Colonialism and the Elimination of the Native." *Journal of Genocide Research*, 8, 4 (2006): 387–409; Lorenzo Veracini, "Introducing: Settler Colonial Studies." *Settler Colonial Studies*, 1 (2011): 1–12; Y. Allard-Tremblay and E. Coburn, "The Flying Heads of Settler Colonialism; or the Ideological Erasures of Indigenous Peoples in Political Theorizing." *Political Studies*, 71, 2 (2023): 359–378; and J. Kēhaulani Kauanui, "'A Structure, Not an Event': Settler Colonialism and Enduring Indigeneity." *Lateral*, 5, 1 (2016).

7 Veracini, 2011.

8 Wolfe, "Settler Colonialism and the Elimination of the Native," 396.

9 Ibid., 389.

10 Michael Sfard, "Border/Barrier," in *The ABC of the OPT: A Legal Lexicon of the Israeli Control Over the Occupied Palestinian Territory*, by Orna Ben-Naftali, Michael Sfard, and Hedi Viterbo (Cambridge: Cambridge University Press, 2018): 46.

11 Ibid.

12 In my previous writing, I outline the ways in which multifaceted discrimination against non-Jewish citizens pervades every corner of Israeli society: from the private to the public sphere, and at social, civil, legal and political levels. In this work I have analyzed, in detail, the ways in which Israel's policy of Jewish privilege is channeled at the declarative level, the structural level, and the operational level. See: *Stateless Citizenship: The Palestinian-Arab Citizens of Israel*, Chapter 2, section titled "A Multifaceted Discrimination" (Leiden: Brill, 2013): 50–97.

13 The relationship among these racially violent and exclusionary political systems becomes increasingly clear when one begins to trace their historical and political interaction. Between 1948–1966, a 'Military Administration' was formed in Israel on the basis of the Emergency Regulations set up during British rule directing them exclusively against the remaining Palestinians within the borders of the newly established state. These laws were geared toward both territorial control and social and demographic dominance over the Palestinians 'inside'—two key political principles guiding the practices of the Jewish State. Fueled by a nationalist settler-colonial project, these apartheid policies were then expanded further into Jerusalem, the West Bank, and the Gaza Strip with the extension of the Israeli military governance regime in 1967. As such, when it comes to examining modern conflict in Israel/Palestine, the entire incorporation regime ought to be conceptualized as implicated in these political systems of oppression. This means that the practices and policies of the Israeli state that apply to non-Jewish citizens, residents and refugees alike are all heightened by the mentioned structures of racialized exclusion and domination—albeit in various ways.

14 See Sara Roy's studies (1987, 2016) on the economic 'de-development' of the Gaza
 Strip.
15 United Nations Trade and Development Board, "Report on UNCTAD Assistance to
 the Palestinian People: Developments in the Economy of the Occupied Palestinian
 Territory." Sixty-Second Session, Geneva, 14–25 September 2015. Retrieved from:
 https://unctad.org/en/PublicationsLibrary/tdb62d3_en.pdf. See also original United
 National Country Team, 2012 Report: https://unsco.unmissions.org/sites/default/
 files/gaza_in_2020_a_liveable_place_english.pdf
16 United National Country Team, 2017 Report. Retrieved form: https://unsco.
 unmissions.org/sites/default/files/gaza_10_years_later_-_11_july_2017.pdf
17 As we will discuss, the blockade prevents the entry of scientific experts relating
 to herbicides/pesticides and laboratory equipment that would allow Palestinian
 agricultural workers, environmental scientists and researchers in Gaza to determine
 the human and environmental health impacts of the sprayed chemicals. Further, the
 electricity shortage and lack of access to non-salienated water heavily impacts the
 ability of Palestinian farmers to irrigate their lands after damage from spraying and
 results in a loss of crops.
18 Following what was dubbed the *Disengagement Plan* in 2005, the uprooting and
 resettlement of 25 Israeli settlements in occupied Gaza that officially ended the
 physical presence of settlement activity inside the strip—and in response to
 numerous petitions filed in the High Court of Justice—the State of Israel has argued
 that it has no obligations or responsibilities under international law toward the
 Palestinian population in Gaza. Israel has since argued that Gaza is no longer under
 military occupation and that the population should therefore direct its claims to
 the Palestinian Authority. Representing itself as a 'service-provider' rather than an
 occupying force with legal humanitarian responsibilities, the Israeli Coordinator
 of Government Activities in the Territories routinely blocks the movement of
 Palestinians to and from Gaza, the import and export of vital goods, and cuts daily
 access to electricity. Yet, as documented by a number of Israeli and Palestinian
 human rights organizations, the source of Israel's obligations toward the population
 in Gaza can be found in both international humanitarian law (IHL) and under
 international human rights law (IHRL). The laws of occupation, incorporated in
 the *Hague Convention (1907)* and the *Fourth Geneva Convention (1949)*, are relevant
 if a state has 'effective control' over a territory. This is determined by the extent
 of its military control and independent of whether said state has a fixed presence
 in the area. Once applied, these laws impose general responsibility on occupying
 states for the safety and welfare of civilians living in the occupied territory. As the
 Israeli NGO B'Tselem explains, "[t]he broad scope of Israeli control in the Gaza
 Strip, which exists despite the lack of a physical presence of [Israeli occupation]
 soldiers in the territory, creates a reasonable basis for the assumption that this
 control amounts to 'effective control.'" Moreover, as IHL is not limited to the status
 of the territory where civilians live, Israel also bears the responsibility to protect
 civilians during an armed conflict. Israel holds that it exists in a state of ongoing
 armed conflict with the Palestinian organizations that control Gaza. As such,
 the Fourth Geneva Convention obliges it to "protect the wounded, sick, children

under age fifteen, and pregnant women, enable the free passage of medicines and essential foodstuffs, enable medical teams to provide assistance, and refrain from imposing collective punishment." A third source for Israeli responsibility towards Palestinians in Gaza is found in IHRL through the Universal Declaration of Human Rights (1948) which recognizes "the right of every person to freedom of movement, to work, to an adequate standard of living, to education, to adequate health care, and to family life." Importantly, and supported by the UN Human Rights Committee, the key determinant delimiting a state's responsibility to a population is not linked to its sovereign jurisdiction but instead to the nature of its control over the population. Working from the above legal and political parameters, this investigation identifies the State of Israel as bearing the responsibilities of an occupying power for the Palestinian population in the Gaza Strip. See: B'Tselem: The Israeli Information Center for Human Rights in the Occupied Territories. "The Gaza Strip—Israel's Obligations Under International Law," Online Report, 1 January 2017. Retrieved from: www.btselem.org/gaza-strip/gaza-strip-israels-obligations-under-international-law; Al-Mezan Center for Human Rights, "Attacks on Unarmed Protesters at 'Great March of Return' Demonstrations, 30 March 2018–28 February 2019," 23 April 2019. Retrieved from: www.mezan.org/en/post/23511/ Attacks+on+Unarmed+Protesters+at+"Great+March+of+Return"+Demonstrations; Gisha Legal Center for Freedom of Movement, "Scale of Control: Israel's Continued responsibility in the Gaza Strip," November 2011. Retrieved from: www.gisha.org/ UserFiles/File/scaleofcontrol/scaleofcontrol_en.pdf

19 The quarterly "Chronology" produced by the *Journal of Palestine Studies* since 1982 was invaluable in my research into the longer history of the systematic flattening and destruction of agricultural lands in Gaza. These chronologies provide rigorous and often daily summaries of the violations of the occupation based on Palestinian, Arab, Israeli, and various international sources. See https://oldwebsite.palestine-studies. org/jps/chronologies

20 "Israeli Military Operations against Gaza, 2000–2008." *Journal of Palestine Studies*, 38, 3 (2009): 122–138.

21 An Ottoman measure of land area that is used in Israel/Palestine today, one dunam is approximately 1,000 square meters, or 4 acres.

22 The Palestinian Ministry of Agriculture estimated the damage at $500 million.

23 United Nations Institute for Training and Research and United Nations Operational Satellite Applications Programme, "Impact of the 2014 Conflict in the Gaza Strip: UNOSAT Satellite Derived Geospatial Analysis," 2014. Retrieved from: https://unosat. web.cern.ch/unosat/unitar/publications/UNOSAT_GAZA_REPORT_OCT2014_WEB. pdf. Emphasis added.

24 Between 2013–2015 on the Egyptian side of Gaza, the Sisi government also heavily flattened large areas of the Egyptian city of Rafah and its neighboring farmlands as part of the military aim of widening its 'buffer zone' with Gaza. By 2015, they announced that the entire city of Rafah would be grazed, and the population relocated.

25 Al-Mezan Center for Human Rights and Al Haq Legal Center, "Letter to Hilal Elver, UN Special Rapporteur on the Right to Food and Baskut Tuncak, UN Special Rapporteur on Human Rights and Hazardous Substances and Wastes," 31 October 2016. Retrieved from: www.mezan.org/en/index.php/post/21599/ Al+Mezan+and+Al-Haq+submit+to+UN+Special+Procedures+on+the+situation+ of+Palestinian+farmers+in+Gaza+whose+fields+and+livelihoods+have+been+affe

cted+by+aerial+spraying+of+chemicals+by+Israeli+aircraft

26 Raf Sanchez, "Israel Unveils Plans for 40-Mile Underground Wall Around Gaza," *Telegraph*, 18 January 2018. Retrieved from: www.telegraph.co.uk/news/2018/01/18/israel-unveils-plans-40-mile-underground-wall-around-gaza/

27 J. Sowers L., Weinthal, E., and Zawahri, N., "Targeting Environmental Infrastructures, International Law, and Civilians in the New Middle Eastern Wars." *Security Dialogue*, 48, 5 (2017): 424.

28 "The Wretched Earth Botanical Conflicts and Artistic Interventions," Introduction. Ros Gray and Shela Sheikh (Eds.), *Third Text*, 32, 2–3 (2018).

29 Upamanyu Pablo Mukherjee, *Postcolonial Environments: Nature, Culture, and the Contemporary Indian Novel in English* (London: Palgrave Macmillan, 2010): 68.

30 Wolfe, 1999.

31 Diana K. Davis, "Imperialism, Orientalism, and the Environment in the Middle East: History, Policy, Power, and Practice," in Diana K. Davis and Edmund Burke III (Eds.), *Environmental Imaginaries of the Middle East and North Africa* (Athens: Ohio University Press: 2011): 4.

32 This observation, also made by other scholars, is further elaborated upon by Andrew Sluyter who recounts that: "Despite a congenital relationship between colonization and geographic scholarship, and despite the significance of colonial landscape transformation to current social and environmental challenges, a comprehensive geographic theory of colonialism and landscape remains incipient at best." "Colonialism and Landscape in the Americas: Material/Conceptual Transformations and Continuing Consequences." *Annals of the Association of American Geographers*, 91, 2 (June 2001): 410. Much scholarship exists on the links between colonialism and landscape, and the colonial formations of landscapes, but a meaningful theoretical framework for understanding the function of landscapes as a medium and method of power in post-colonial contexts is largely absent in the literature, and particularly in scholarship looking at colonial legacies in the Middle East and North Africa.

33 W.J.T. Mitchell, "Showing Seeing: A Critique of Visual Culture." *Journal of Visual Culture*, 1, 2 (2002): 165.

34 For elaboration on colonial legacies and hegemonic representations of the Middle East, see the works of Yaseen Noorani, *Culture and Hegemony in the Colonial Middle East* (London: Palgrave Macmillan: 2010); Ali Behdad and Luke Gartlan, (Eds.). *Photography's Orientalism: New Essays on Colonial Representation* (Los Angeles, Getty Research Institute: 2013); and Diana K. Davis and Edmund Burke III (Eds.), *Environmental Imaginaries of the Middle East and North Africa*.

35 Diana K. Davis and Edmund Burke III (Eds.). *Environmental Imaginaries of the Middle East and North Africa*, 2–3.

36 Shaul Cohen, "Environmentalism Deferred: Israeli/Palestinian Imaginaries," in Diana K. Davis and Edmund Burke III (Eds.). *Environmental Imaginaries of the Middle East and North Africa*, 249.

37 See the work of Walter Lehn, "The Jewish National Fund." *Journal of Palestine Studies*, 3, 4 (Summer 1974): 74–96; and Walter Lehn and Uri Davis, *The Jewish National Fund* (London: Kegan Paul International, 1988).

38 Alon Tal, *Pollution in a Promised Land* (Berkeley: University of California Press, 2002): 82.

39 Jewish National Fund UK website: www.jnf.co.uk/

40 Guntrum Herb and David H. Kaplan (Eds.), *Nested Identities: Nationalism, Territory and Scale* (London: Rowman & Littlefield Pub Inc.,1999): 23; Mitchell (2002: 166).

41 Pines also damaged indigenous ecosystems: fallen needles create a poisonous ground cover that prevents other plants and most animals from surviving, while the process of preparing land for planting—strategic fires, heavy machinery and pesticides—stripped the soil. See Tal, 2002: 94–95.

42 According to Mustafa Kabha and Nahum Karlinsky, "One of the many explanations for the name is its connection to the Shamouti family, a family of *bayariya* [grove managers] based in Lydda and Jaffa. However, as of today there is no sound scholarly explanation for the origins of this name." *The Lost Orchard: The Palestinian-Arab Citrus Industry*, 1850–1950, (Syracuse: Syracuse University Press, 2021): 156.

43 Ibid., 18.

44 Ibid., 1.

45 Ibid., 39–40. The continue to explain that "The hourly wages of Jewish laborers were considerably higher than those of the Arab laborers, though they performed the exact same job. The reasons for this were manifold—economic, ideological, social, and cultural—and as stated, considerable research attention has been devoted to this issue. In any case, although until World War I the supply of Jewish labor was very low and provided no more than about 10 percent of total demand for workers in the Zionist citrus industry (as shown by Israel Kolatt many years ago), this fact also affected the wages of Arab workers in the Zionist sector. Thus, the wages of Arab workers in the Jewish industry were higher than those of Arab workers in the Palestinian-Arab industry for the same jobs."

46 Ibid., 42.

47 Ibid., 56.

48 Ibid., 59.

49 Ibid.

50 Much has been written on the Israeli colonial category of 'present-absentees,' a classification that Palestinians were unilaterally given by the State of Israel rendering them internally displaced refugees after being expelled from their homes and lands and prevented to returning. See, for example, Shira Robinson, *Citizen Strangers: Palestinians and the Birth of Israel's Liberal Settler State* (Stanford: Stanford University Press, 2013); Nur Masalha (Ed.). *Catastrophe Remembered: Palestine, Israel and the Internal Refugees: Essays in Memory of Edward W. Said (1935–2003)* (London: Zed Books, 2005); Adel Manna, *Nakba and Survival: The Story of Palestinians Who Remained in Haifa and the Galilee*, 1948–1956 (Berkeley: University of California Press, 2022).

51 Archival posters from the Palestinian political movement Fatah, the Democratic Front for the Liberation of Palestine and the Popular Front for the Liberation of Palestine show that on all major days of action, *Nakba Day, International Women's Day, Land Day*, and *Prisoners Day*, oranges and citrus production resurfaces as a symbol of resistance, steadfastness and return to Palestine (see The Palestine Project Archives, www.palestineposterproject.org/).

52 Ann M. Lesch, "Gaza: Forgotten Corner of Palestine." *Journal of Palestine Studies*, 15, 1 (Autumn 1985): 45.

53 Ibid., 46.

54 Ibid., 47.

55 Ibid.

56 United Nations Office for the Coordination of Humanitarian Affairs, "Between the Fence and a Hard Place: The Humanitarian Impact of Israeli-Imposed Restrictions on Access to Land and Sea in the Gaza Strip," Special Focus Report, August 2010. Retrieved from: www.un.org/unispal/document/auto-insert-196584/

57 Al-Mezan Center for Human Rights. "Effects of Aerial Spraying on Farmlands in the Gaza Strip." Briefing Paper, February 2018. Retrieved from: www.mezan.org/en/uploads/files/15186958401955.pdf

58 Alessio Perrone, "Cacti replacing snow on Swiss mountainsides due to global heating," *Guardian Online*, 10 February 2023. Retrieved from: www.theguardian.com/environment/2023/feb/10/cacti-replacing-snow-on-swiss-mountainsides-due-to-global-heating

59 Ibid.

60 Giulia Grechi, "Colonial Cultural Heritage and Embodied Representations: Throwing the Body into the Struggle," in The Black Mediterranean Collective (Eds.). *The Black Mediterranean: Bodies, Borders, and Citizenship* (London: Palgrave Macmillan, 2021), 89.

61 This designation has been widely condemned around the world, including by prominent international NGOs, such as Amnesty International and Human Rights Watch, as well as governmental offices and representatives—such as Sweden's Minister of International Development Cooperation and Humanitarian Affairs, the High Representative of the EU for Foreign Affairs and Security Policy, Ireland's Minister of Foreign Affairs and Minister of Defence, the French Ministry of Foreign Affairs, the EU Special Representative for Human Rights, and U.S. Congressional representatives. UN experts, such as the UN High Commissioner for Human Rights and the UN Special Rapporteur for Freedom of Association have also condemned this designation of Al-Haq and the other groups, as well as local Israeli human rights organizations like B'Tselem.

62 The work of Ahmad Amara stands out in what is often called Bedouin or Negev Studies and the colonial frameworks within which this scholarship is produced, see for example "Privileging agriculture in Southern Palestine," Draft paper, (2017); "Beyond Stereotypes of Bedouins as 'Nomads' and 'Savages': Rethinking the Bedouin in Ottoman Southern Palestine, 1875–1900." *Journal of Holy Land and Palestine Studies*, 15, 1 (2016); "The Negev Land Question: Between Denial and Recognition." *Journal of Palestine Studies*, 42, 4 (2013): 27–47; and with Oren Yiftachel and Alexandre Kedar, *Emptied Lands: A Legal Geography of Bedouin Rights in the Negev* (Stanford: Stanford University Press, 2018).

63 Oliver Belcher, "Anatomy of a Village Razing: Counterinsurgency, Violence, and Securing the Intimate in Afghanistan." *Political Geography*, 62 (January 2018): 99.

64 Ibid., 102.

65 Jens Haendeler, Alex Ioannou, and Anushka Athique, "Weaponised Landscapes: Mapping the Calais 'Jungle.'" *Other Sides* (2017): 22–29.

66 Ibid., 26.

67 Clyde Haberman, "Agent Orange's Long Legacy, for Vietnam and Veterans," *New York Times*, 11 May 2014. Retrieved from: www.nytimes.com/2014/05/12/us/agent-oranges-long-legacy-for-vietnam-and-veterans.html; see also William A. Buckingham Jr., *Operation Ranch Hand: The Air Force and Herbicides in Southeast Asia, 1961–1971* (CreateSpace Independent Publishing Platform, 1982).

68 Jeremy Wallace, "Texas Senate Approves Using Herbicides to Fight Illegal Border Crossings," *Houston Chronicle*, 29 April 2019. Retrieved from: www.houstonchronicle.com/news/politics/texas/article/Texas-Senate-approves-using-herbicides-to-fight-13804919.php

69 The work of Maria Puig de la Bellacasa is particularly relevant here in thinking about soil and violence against it as part of an attack on an entire ecology, thereby

engaging with soil as a living community rather than a receptacle for crops.

70 See Jillian Kestler-D'Amours, "Gaza Farmers Seek Damages for Israel's Crop-Spraying," *Al-Jazeera Online*, 14 July 2016. Retrieved from: www.aljazeera.com/news/2016/7/14/gaza-farmers-seek-damages-for-israels-crop-spraying. The Gisha Legal Center for Freedom of Movement and Al-Mezan Center for Human Rights have also extensively documented the history of Israeli herbicide spraying around Gaza.

71 Michael Schaeffer Omer-Man, "IDF Admits Spraying Herbicides Inside the Gaza Strip," +972 *Magazine Online*, 28 December 2015. Retrieved from: https://972mag.com/idf-admits-spraying-herbicides-inside-the-gaza-strip/115290/

72 Ministry of Defense Freedom of Information Response to Gisha, November 2016.

73 Ibid.

74 Ibid.

75 A Bedouin-specific patrol unit of the Israeli police.

76 Ministry of Defense Freedom of Information Response to Gisha, November 2016.

77 Ministry of Defense Freedom of Information Response to Gisha, February 2019.

78 World Health Organization, International Agency for Research on Cancer, "Monograph on Glyphosate," Volume 112, 20 March 2015. Retrieved from: www.iarc.fr/wp-content/uploads/2018/07/MonographVolume112-1.pdf

79 Tapazol Chemical Works Ltd. "Oxygal-Material Safety Data Sheet," 8 August 2011.

80 Al-Mezan Center for Human Rights, "Effects of Aerial Spraying on Farmlands in the Gaza Strip."

81 Ministry of Defense Freedom of Information Response to Gisha, November 2016. Emphasis added.

82 Alan G. Dexter, "Herbicide Spray Drift," North Dakota State University, August 1993. Retrieved from: https://library.ndsu.edu/ir/bitstream/handle/10365/3067/126dex93.pdf?sequence=1

83 Amira Hass, "Farm Warfare: How Israel Uses Chemicals to Kill Crops in Gaza," *Haaretz Online*, 9 July 2018. Retrieved from: www.haaretz.com/middle-east-news/palestinians/.premium-farm-warfare-how-israel-uses-chemicals-to-kill-crops-in-gaza-1.6245475

84 Ministry of Defense Freedom of Information Response to Gisha, November 2016. Emphasis added.

85 The inclusion of compensation mechanisms in the MOD's protocols for aerial herbicide spraying also reasonably imply its own tacit acknowledgment that the effects of the practice on neighboring farmlands may not be fully controllable.

86 Al-Mezan, "Effects of Aerial Spraying on Farmlands in the Gaza Strip."

87 Al-Mezan and Al Haq, "Letter to Hilal Elver."

88 Ibid.

89 Ibid.

90 Al-Mezan, "Effects of Aerial Spraying on Farmlands in the Gaza Strip."

91 Gisha Legal Center for Freedom of Movement, "Gaza Farmers Assess the Damage After Another Round of Herbicide Spraying," 1 February 2017. Retrieved from: http://gisha.org/updates/5776

92 Nir Hasson, "Bedouin Petition Court Against ILA Crop Spraying," *Haaretz Online*, 22 March 2004. Retrieved from: www.haaretz.com/1.4761557. 'Unrecognized villages' are villages of Palestinian Bedouin citizens of Israel that are considered 'illegal' by the Israeli State, and therefore denied basic governmental services like electricity, running water, garbage collection, infrastructural support, education, health and other social services. This racialized policy of an imposed 'illegality' is also

complemented with the continuous threat of home demolition, crop destruction, and displacement.

93 Among other laws, the State cited *Land Law, 5729-1969, Public Land Law* (Eviction of Squatters), *5741-1981, Plant Protection Law, 5716-1956,* Regulation 12 of the *Plant Protection Regulations* (Use of Herbicides), *5729-1969, and Emergency Regulations, 1945.*

94 United States Department of State. Bureau of Democracy, Human Rights, and Labor, 2004 Country Report. "Human Rights Practices in Israel and the OPT: Country Reports on Human Rights Practices." Retrieved from: www.un.org/unispal/document/auto-insert-200003/

95 Al-Mezan Center for Human Rights, Adalah Legal Center for Arab Minority Rights, Gisha Legal Center for Freedom of Movement. "Letter to Ministry of Defense, Re: Spraying in the Gaza Strip Resulting in Damage to Crops and Harm to the Health of Gaza Residents," 7 January 2019. Retrieved from: https://gisha.org/UserFiles/File/Legal%20Documents/Al_Mezan_Gisha_Adalah_letter_re_spraying_190107.pdf

96 Adalah Legal Center for Arab Minority Rights, *Saleem Abu Medeghem, et. al. v. Israel Lands Administration, et. al.* [H.C. 2887/04] 102–103, no. 28.

97 Ibid., 110, no. 38.

98 Ibid., 102–103, no. 28.

99 Ibid., 104.

100 Ibid.

101 Assisted by Dr. Samaneh Moafi, Forensic Architecture.

102 Assisted by Dr. Salvador Navarro-Martinez, Imperial College London.

103 EU Policy on glyphosate drift retrieved from "Renewal Assessment Report: Toxicology and Metabolism," Volume 3, Annex B.6.1, (18 December 2013). Retrieved from: https://corporateeurope.org/sites/default/files/attachments/glyphosate_rar_08_volume_3ca-cp_b-6_2013-12-18_san.pdf

104 Led by Forensic Architecture. Assisted by Corey Scher, City University of New York.

105 Assisted by Shurouq Alaila.

106 Ministry of Defense Freedom of Information Response to Gisha, February 2019.

107 Following the instructions of an Extension Weed Specialist, leaves were collected from various types of similar low-growing crops from each site. The leaves were cut with a scissors and placed in sealable plastic bags from each collection site in East Gaza and Juhor ad Dik.

108 Photography done by Roshdi Al-Sarraj and *Ain Media Gaza.*

109 See Al-Mezan, Gisha and Adalah, "New Multi-Media Investigation Proves Herbicide Spraying by Israel Near Gaza fence Damages Lands and Crops Deep Inside the Strip," Press Release, 21 July 2019. Retrieved from: www.mezan.org/en/post/23551

110 See United Nations General Assembly, 74th Session, "Report of the Special Committee to Investigate Israeli Practices Affecting the Human Rights of the Palestinian People and Other Arabs of the Occupied Territories," 20 September 2019. Retrieved from: www.un.org/unispal/wp-content/uploads/2019/10/A.74.356.pdf

111 Led by Forensic Architecture. Assisted by Corey Scher, City University of New York.

112 Ibid.

113 Hannah Meszaros Martin, "Defoliating the World: Ecocide, Visual Evidence and Earthly Memory." *Third Text*, 32, 2–3 (2018): 252.

114 Ibid., 253.

115 Achille Mbembe and Carolyn Shread, "The Universal Right to Breathe." *Critical Inquiry*, 47, 2 (Winter 2021): 58–62.

116 See the UN Commission of Inquiry Report. Retrieved from: www.ohchr.org/EN/

HRBodies/HRC/RegularSessions/Session40/Documents/A_HRC_40_74_CRP2.pdf

117 Ibid.

118 Ibid.

119 Ibid.

120 Ghada Majadli and Hadas Ziv, "Amputating the Body, Fragmenting the Nation: Palestinian Amputees in Gaza." *Health Human Rights*, 24, 2 (December 2022): 290.

121 Forensic Architecture, "Matchking: Warren B. Kanders and the Israel Defense Forces," May 2019. Retrieved from: https://forensic-architecture.org/investigation/matchking-warren-b-kanders-and-the-israel-defense-forces

122 Ibid.

123 Testimony shared with the author from medical practitioner Riccardo Corradini and filmmakers Chiara Avesani and Matteo Delbo. Source: https://forensic-architecture.org/investigation/matchking-warren-b-kanders-and-the-israel-defense-forces

124 Ibid.

125 Testimony shared with the author and sourced in: https://forensic-architecture.org/investigation/matchking-warren-b-kanders-and-the-israel-defense-forces

126 Ibid.

127 See Forensic Architecture, "Matchking: Warren B. Kanders and the Israel Defense Forces," May 2019. Retrieved from: https://forensic-architecture.org/investigation/matchking-warren-b-kanders-and-the-israel-defense-forceshttps://forensic-architecture.org/investigation/matchking-warren-b-kanders-and-the-israel-defense-forces.

128 See Forensic Architecture, "Living Archaeology in Gaza," February 2022: https://forensic-architecture.org/investigation/living-archaeology-in-gazahttps://forensic-architecture.org/investigation/living-archaeology-in-gaza

Bibliography

Adalah Legal Center for Arab Minority Rights. *Saleem Abu Medeghem, et. al. v. Israel Lands Administration, et. al.* [H.C. 2887/04].

Al-Mezan Center for Human Rights and Al Haq Legal Center. "Letter to Hilal Elver, UN Special Rapporteur on the Right to Food and Baskut Tuncak, UN Special Rapporteur on Human Rights and Hazardous Substances and Wastes." 31 October 2016. Retrieved from: www.mezan.org/en/index.php/post/21599/Al+Mezan+and+Al-Haq+submit+to+UN+Special+Procedures+on+the+situation+of+Palestinian+farmers+in+Gaza+whose+fields+and+livelihoods+have+been+affected+by+aerial+spraying+of+chemicals+by+Israeli+aircraft

Al-Mezan Center for Human Rights. "Effects of Aerial Spraying on Farmlands in the Gaza Strip." Briefing Paper, February 2018. Retrieved from: www.mezan.org/en/uploads/files/15186958401955.pdf

Al-Mezan Center for Human Rights, "Attacks on Unarmed Protesters at 'Great March of Demonstrations, 30 March 2018–28 February 2019," 23 April 2019. Retrieved from: www.mezan.org/en/post/23511/Attacks+on+Unarmed+Protesters+at+"Great+March+of+Return"+Demonstrations

Al-Mezan Center for Human Rights, Gisha Legal Center for Freedom of Movement and Adalah Legal Center for Arab Minority Rights. "New multi-media investigation proves herbicide spraying by Israel near Gaza fence damages lands and crops deep inside the Strip," Press Release, 21 July 2019. Retrieved from: www.mezan.org/en/post/23551

Allard-Tremblay Y. and Coburn, E. "The Flying Heads of Settler Colonialism; or the Ideological Erasures of Indigenous Peoples in Political Theorizing." *Political Studies*, 71, 2 (2023): 359–378.

A.M. Qattan Foundation. *Weed Control*. "Curatorial Statement." Exhibition. Ramallah, Palestine, 2020.

Amara, Ahmad. "The Negev Land Question: Between Denial and Recognition." *Journal of Palestine Studies*, 42, 4 (2013): 27–47.

Amara, Ahmad. "Beyond Stereotypes of Bedouins as 'Nomads' and 'Savages': Rethinking the Bedouin in Ottoman Southern Palestine, 1875–1900." *Journal of Holy Land and Palestine Studies*, 15, 1 (2016).

Amara, Ahmad. "Privileging Agriculture in Southern Palestine." Draft Paper (2017).

Amara, Ahmad, Yiftachel, Oren, and Kedar, Alexandre. *Emptied Lands: A Legal Geography of Bedouin Rights in the Negev*. Stanford: Stanford University Press, 2018.

Bacon, J. M. "Settler Colonialism as Eco-Social Structure and the Production of Colonial Ecological Violence." *Environmental Sociology*, 5, 1 (2018): 59–69.

Behdad Ali and Gartlan, Luke (Eds.). *Photography's Orientalism: New Essays on Colonial Representation*. Los Angeles: Getty Research Institute, 2013.

Belcher, Oliver. "Anatomy of a Village Razing: Counterinsurgency, Violence, and Securing the Intimate in Afghanistan." *Political Geography*, 62 (January 2018): 94–105.

B'Tselem: The Israeli Information Center for Human Rights in the Occupied Territories. "The Gaza Strip—Israel's Obligations Under International Law,"

Online Report, 1 January 2017. Retrieved from: www.btselem.org/gaza-strip/gaza-strip-israels-obligations-under-international-law

Buckingham Jr., William A. *Operation Ranch Hand: The Air Force and Herbicides in Southeast Asia, 1961–1971*. South Carolina: CreateSpace Independent Publishing Platform, 1982.

Davis, Diana K. and Burke III, Edmund (Eds.). *Environmental Imaginaries of the Middle East and North Africa*. Athens: Ohio University Press, 2011.

Dexter, Alan G. "Herbicide Spray Drift." North Dakota State University, August 1993. Retrieved from: https://library.ndsu.edu/ir/bitstream/handle/10365/3067/126dex93.pdf?sequence=1

Forensic Architecture. "Matchking: Warren B. Kanders and the Israel Defense Forces," May 2019. Retrieved from: https://forensic-architecture.org/investigation/matchking-warren-b-kanders-and-the-israel-defense-forces

Gisha Legal Center for Freedom of Movement, "Scale of Control: Israel's Continued responsibility in the Gaza Strip," November 2011. Retrieved from: www.gisha.org/UserFiles/File/scaleofcontrol/scaleofcontrol_en.pdf

Gisha Legal Center for Freedom of Movement, "Al-Haq's Rejoinder to Gisha's 'Scale of Control' Report: Israel's Continued Responsibility as the Occupying Power in the Gaza Strip," 18 December 2011. Retrieved from: https://gisha.org/en-blog/2011/12/18/al-haqs-rejoinder-to-gishas-scale-of-control-report-israels-continued-responsibility-as-the-occupying-power-in-the-gaza-strip/

Gisha Legal Center for Freedom of Movement. Freedom of Information Response by Israeli Ministry of Defense, November 2016.

Gisha Legal Center for Freedom of Movement. Freedom of Information Response by Israeli Ministry of Defense, February 2019.

Gisha Legal Center for Freedom of Movement, "Gaza farmers assess the damage after another round of herbicide spraying," 1 February 2017. Retrieved from: http://gisha.org/updates/5776

Gray, Ros and Sheikh, Shela, Eds. "The Wretched Earth Botanical Conflicts and Artistic Interventions." *Third Text*, 32, 2–3 (2018).

Grechi, Giulia. "Colonial Cultural Heritage and Embodied Representations: Throwing the Body into the Struggle." In *The Black Mediterranean: Bodies, Borders, and Citizenship*. The Black Mediterranean Collective, Eds. London: Palgrave Macmillan, 2021: 83–98.

Haberman, Clyde. "Agent Orange's Long Legacy, for Vietnam and Veterans." *New York Times*, 11 May 2014, retrieved from: www.nytimes.com/2014/05/12/us/agent-oranges-long-legacy-for-vietnam-and-veterans.html

Haendeler, Jens, Alex Ioannou, and Anushka Athique. "Weaponised Landscapes: Mapping the Calais 'Jungle.'" *Other Sides* (2017): 22–29.

Hass, Amira. "Farm Warfare: How Israel Uses Chemicals to kill Crops in Gaza." *Haaretz Online*, 9 July 2018. Retrieved from: www.haaretz.com/middle-east-news/palestinians/.premium-farm-warfare-how-israel-uses-chemicals-to-kill-crops-in-gaza-1.6245475

Hasson, Nir. "Bedouin Petition Court Against ILA Crop Spraying." *Haaretz Online*, 22 March 2004. Retrieved from: www.haaretz.com/1.4761557

Herb, Guntrum and Kaplan, David H. (Eds.). *Nested Identities: Nationalism, Territory and Scale*. London: Rowman & Littlefield Pub Inc., 1999.

Herzl, Theodor. *Altneuland*. Translated by Miriam Kraus. Bavel, 2002 (1902). Retrieved from: www.jnf.co.uk/

Journal of Palestine Studies. "Israeli Military Operations against Gaza, 2000–2008." *Journal of Palestine Studies*, 38, 3 (2009): 122–138.

Kabha, Mustafa and Nahum Karlinsky. *The Lost Orchard: The Palestinian-Arab Citrus Industry, 1850–1950*. Syracuse: Syracuse University Press, 2021.

Kauanui, J. Kēhaulani. "'A Structure, Not an Event': Settler Colonialism and Enduring Indigeneity." *Lateral* 5, 1 (2016).

Kestler-D'Amours, Jillian. "Gaza Farmers Seek Damages for Israel's Crop-Spraying." *Al-Jazeera Online*. 14 July 2016. Retrieved from: www.aljazeera.com/news/2016/7/14/gaza-farmers-seek-damages-for-israels-crop-spraying

Lehn, Walter. "The Jewish National Fund." *Journal of Palestine Studies*, 3, 4 (Summer 1974): 74–96.

Lehn, Walter and Davis, Uri. *The Jewish National Fund*. London: Kegan Paul International, 1988.

Lesch, Ann M. "Gaza: Forgotten Corner of Palestine." *Journal of Palestine Studies*, 15, 1 (Autumn, 1985): 43–61.

Majadli, Ghada and Ziv, Hadas. "Amputating the Body, Fragmenting the Nation: Palestinian Amputees in Gaza." *Health Human Rights*, 24, 2 (December 2022): 281–292.

Manna, Adel. *Nakba and Survival: The Story of Palestinians Who Remained in Haifa and the Galilee, 1948–1956*. California: University of California Press, 2022.

Martin, Hannah Meszaros. "Defoliating the World: Ecocide, Visual Evidence and Earthly Memory." *Third Text*, 32, 2–3 (2018): 230–253.

Masalha, Nur (Ed.). *Catastrophe Remembered: Palestine, Israel and the Internal Refugees: Essays in Memory of Edward W. Said (1935–2003)*. London: Zed Books, 2005.

Mbembe, Achille and Shread, Carolyn. "The Universal Right to Breathe." *Critical Inquiry*, 47, 2 (Winter 2021): 58–62.

Mitchell, W.J.T. "Showing Seeing: A Critique of Visual Culture." *Journal of Visual Culture* 1, 2 (2002): 165–181.

Mustard and Cress (P.E.F. Cressall). *Palestine Parodies Being the Holy Land in Verse and Worse*. Jerusalem: Azriel Press, private edition, 1938.

Molavi, Shourideh C. *Stateless Citizenship: The Palestinian-Arab Citizens of Israel*. Leiden, Netherlands: Brill Academic Publishers, 2013.

Mukherjee, Upamanyu Pablo. *Postcolonial Environments: Nature, Culture, and the Contemporary Indian Novel in English*. London: Palgrave Macmillan, 2010.

Noorani, Yaseen. *Culture and Hegemony in the Colonial Middle East*. London: Palgrave Macmillan, 2010.

Perrone, Alessio. "Cacti Replacing Snow on Swiss Mountainsides due to Global Heating." *Guardian Online*. 10 February 2023. Retrieved from: www.theguardian.com/environment/2023/feb/10/cacti-replacing-snow-on-swiss-mountainsides-due-to-global-heating

"Renewal Assessment Report: Toxicology and Metabolism," Volume 3, Annex B.6.1 (18 December 2013). Retrieved from: https://corporateeurope.org/sites/default/files/attachments/glyphosate_rar_08_volume_3ca-cp_b-6_2013-12-18_san.pdf

Robinson, Shira. *Citizen Strangers: Palestinians and the Birth of Israel's Liberal Settler*

State. Stanford: Stanford University Press, 2013.

Roy, Sara. "The Gaza Strip: A Case of Economic De-Development," *Journal of Palestine Studies*, 17, 1 (Autumn, 1987): 56–88.

Roy, Sara. *The Gaza Strip: The Political Economy of De-Development (Expanded Third Edition)*. Beirut: Institute for Palestine Studies, 2016.

Sanchez, Raf. "Israel unveils plans for 40-mile underground wall around Gaza." *Telegraph*, 18 January, 2018. Retrieved from: www.telegraph.co.uk/news/2018/01/18/israel-unveils-plans-40-mile-underground-wall-around-gaza/

Schaeffer Omer-Man, Michael. "IDF Admits Spraying Herbicides Inside the Gaza Strip." +972 *Magazine Online*, 28 December 2015, Retrieved from: https://972mag.com/idf-admits-spraying-herbicides-inside-the-gaza-strip/115290/

Sfard, Michael. "Border/Barrier" in *The ABC of the OPT: A Legal Lexicon of the Israeli Control Over the Occupied Palestinian Territory*, pp. 43–59. Cambridge: Cambridge University Press, 2018.

Sluyter, Andrew. "Colonialism and Landscape in the Americas: Material/Conceptual Transformations and Continuing Consequences." *Annals of the Association of American Geographers*, 91, 2 (June 2001): 410–428.

Sowers, J. L., Weinthal, E., and Zawahri, N. "Targeting Environmental Infrastructures, International Law, and Civilians in the New Middle Eastern Wars." *Security Dialogue*, 48, 5 (2017): 410–430.

Tal, Alon. *Pollution in a Promised Land*. Berkeley: University of California Press, 2002.

United Nations Educational, Scientific and Cultural Organization. United National Country Team, 2012 Report. Retrieved from: https://unsco.unmissions.org/sites/default/files/gaza_in_2020_a_liveable_place_english.pdf

United Nations Educational, Scientific and Cultural Organization. United National Country Team, 2017 Report. Retrieved from: https://unsco.unmissions.org/sites/default/files/gaza_10_years_later_-_11_july_2017.pdf

United Nations General Assembly. 74th Session. "Report of the Special Committee to Investigate Israeli Practices Affecting the Human Rights of the Palestinian People and Other Arabs of the Occupied Territories." 20 September 2019. Retrieved from: www.un.org/unispal/wp-content/uploads/2019/10/A.74.356.pdf

United Nations Human Rights Council, Commission of Inquiry, "Report of the Detailed Findings of the Independent International Commission of Inquiry on the Protests in the Occupied Palestinian Territory," 18 March 2019 [A/HRC/40/74]. Retrieved from: www.ohchr.org/EN/HRBodies/HRC/RegularSessions/Session40/Documents/A_HRC_4074_CRP2.pdf

United Nations Institute for Training and Research and United Nations Operational Satellite Applications Programme. "Impact of the 2014 Conflict in the Gaza Strip: UNOSAT Satellite Derived Geospatial Analysis." 2014. Retrieved from: https://unosat.web.cern.ch/unosat/unitar/publications/UNOSAT_GAZA_REPORT_OCT2014_WEB.pdf

United Nations Office for the Coordination of Humanitarian Affairs. "Between the Fence and a Hard Place: The Humanitarian Impact of Israeli-Imposed Restrictions on Access to Land and Sea in the Gaza Strip." Special Focus Report, August 2010. Retrieved from: www.un.org/unispal/document/auto-insert-196584/

United Nations Trade and Development Board, "Report on UNCTAD Assistance to the Palestinian People: Developments in the Economy of the Occupied Palestinian Territory," Sixty-Second Session, Geneva, 14–25 September 2015. Retrieved from: https://unctad.org/system/files/official-document/tdbex72d2_en.pdf

United States Department of State. Bureau of Democracy, Human Rights, and Labor, 2004 Country Report. "Human Rights Practices in Israel and the OPT: Country Reports on Human Rights Practices." Retrieved from: www.un.org/unispal/document/auto-insert-200003/

Veracini, Lorenzo. "Introducing: Settler-Colonial Studies." *Settler Colonial Studies*, 1 (2011): 1–12.

Wallace, Jeremy. "Texas Senate Approves Using Herbicides to Fight Illegal Border Crossings." *Houston Chronicle*, 29 April 2019. Retrieved from: www.houstonchronicle.com/news/politics/texas/article/Texas-Senate-approves-using-herbicides-to-fight-13804919.php

Whyte, Kyle. "Settler Colonialism, Ecology, and Environmental Injustice." *Environment and Society*, 9, 1 (Sep 2018): 125–144.

Wolfe, Patrick. *Settler Colonialism and the Transformation of Anthropology*. London: Cassell 1999.

Wolfe, Patrick. "Settler Colonialism and the Elimination of the Native." *Journal of Genocide Research*, 8, 4 (2006): 387–409.

World Health Organization, International Agency for Research on Cancer. "Monograph on Glyphosate," Volume 112, 20 March 2015. Retrieved from: www.iarc.fr/wpcontent/uploads/2018/07/MonographVolume112-1.pdf